PAINTING WATERCOLOR FLORALS That Glow

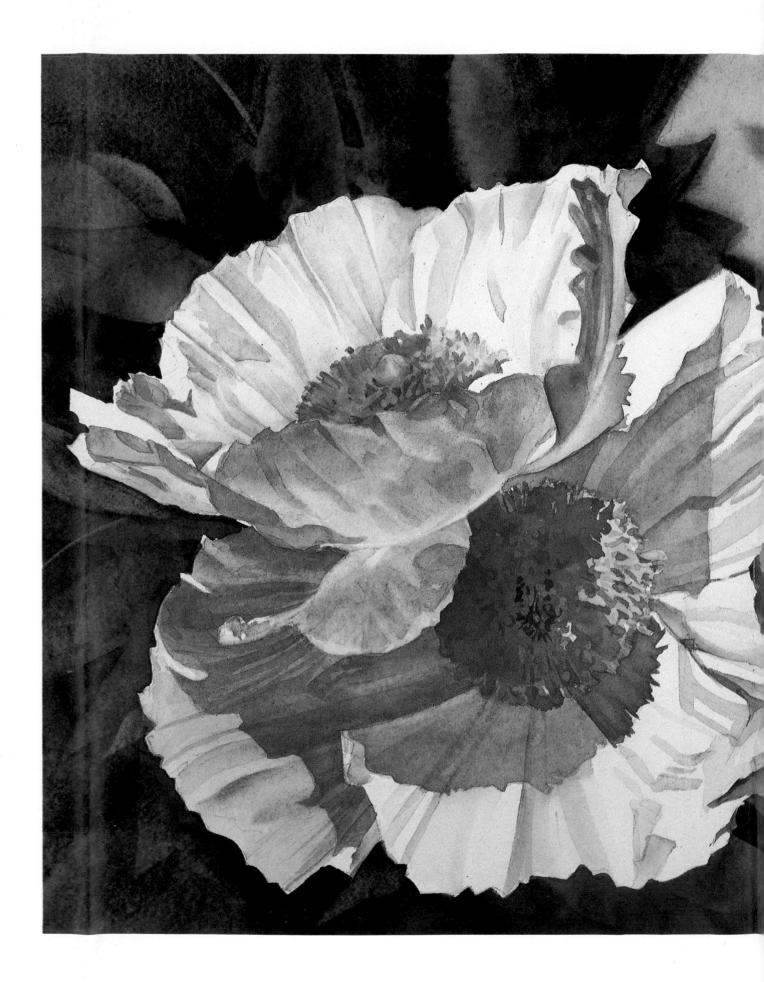

PAINTING WATERCOLOR FLORALS That Glow

JAN KUNZ

Cincinnati, Ohio

About the Author

Jan Kunz was raised in southern California and received her education at UCLA. Any leisure time she could find during the busy years of raising a family and juggling a career in commercial art were spent painting in watercolor. In 1978, she began to devote all of her time to her new career.

She has traveled widely, painting everything from the lighthouses along the California and Oregon coast to robed men walking the streets of Alexandria, Egypt. When not painting for shows and galleries, Jan is teaching watercolor workshops. She is the author of *Painting Watercolor Portraits That Glow* as well as two workbooks: *Painting the Still Life* and *Painting Children's Portraits*.

Jan lives with her husband, Bill, on the Oregon coast.

Painting Watercolor Florals That Glow. Copyright © 1993 by Jan Kunz. Printed and bound in the United States of America. All rights reserved. No part of this book may be reproduced in any form or by any electronic or mechanical means including information storage and retrieval systems without permission in writing from the publisher, except by a reviewer, who may quote brief passages in a review. Published by North Light Books, an imprint of F&W Publications, Inc., 1507 Dana Avenue, Cincinnati, Ohio 45207. 1-800-289-0963. First edition.

97 96 95 94 93 5 4 3 2 1

Library of Congress Cataloging in Publication Data

Kunz, Jan.
Painting watercolor florals that glow / Jan Kunz. — 1st ed.
p. cm.
Includes index.
ISBN 0-89134-473-X
1. Flowers in art. Watercolor painting — Technique. I. Title.
ND2300.K86 1993
751.42'2434 — dc20

93-22370 CIP

Edited by Rachel Wolf Designed by Sandy Conopeotis

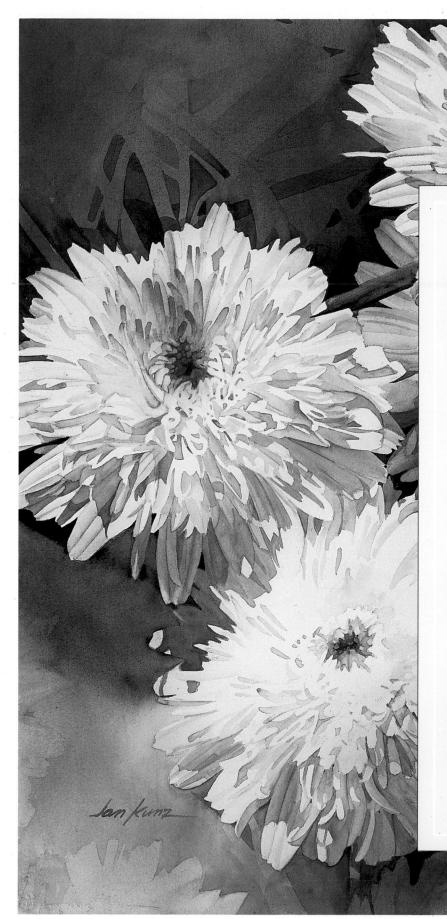

Acknowledgments

Sincere thanks to the people who helped put this book together. Editor Rachel Wolf kept us organized with her calm, reassuring manner and enormous editorial skill. Kathy Kipp was entrusted with all the details of the final content edit. I have worked with Rachel, Kathy and senior editor Greg Albert before, so there was a lot of security knowing I could count on them to be there. Beth Johnson was the production editor and Sandy Conopeotis designed the pages and was responsible for the book's final appearance.

A special thanks to my husband, Bill, who never complained about my long hours and did everything from proofreading the text to shopping for groceries.

Dedication

Dedicated to my daughter, Lynn, and all the rest of the painters like her who snatch scraps of time from impossibly busy schedules and still produce beautiful art. I hope this book is an inspiration to keep painting Your best work is yet to come.

Moonlight Mums, 30"x22"

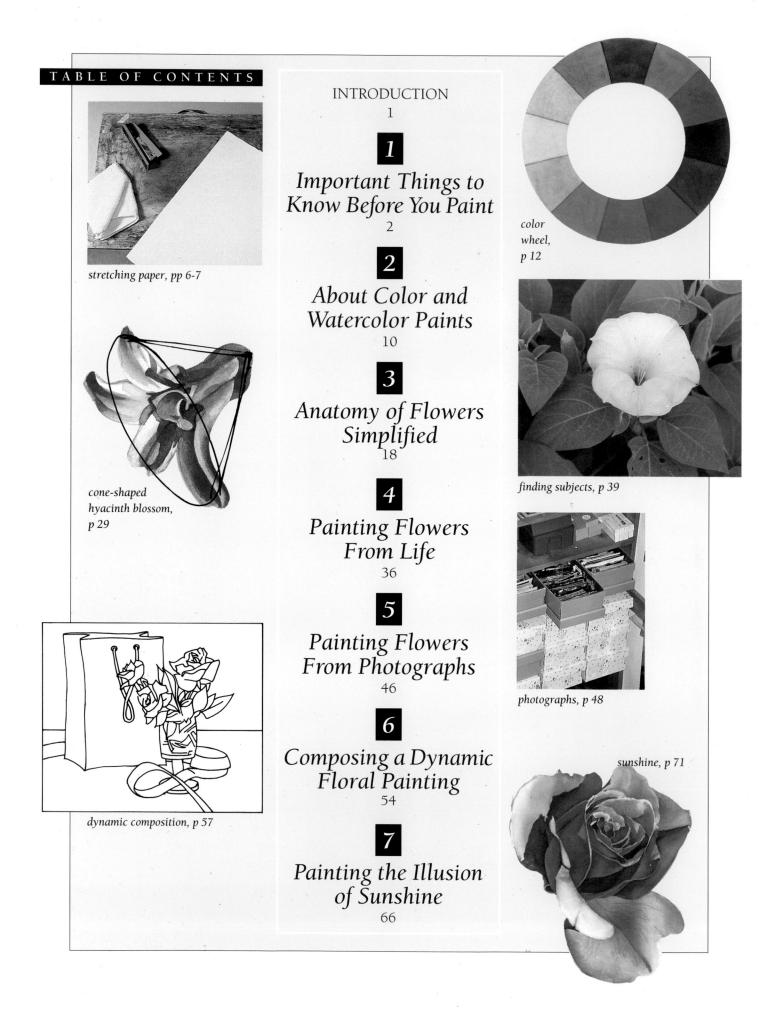

dew drops, p 98

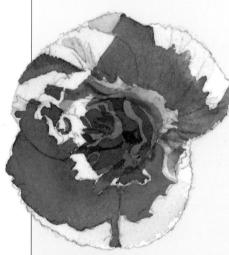

backlighting, p 105

8 Reference of Essential Floral Painting Techniques 76

backgrounds 82 backlighting 105 cast shadows 90 charging color 80 cluster blooms 91 convex and concave curves 93 curled edges 86 dewdrops 98 glazing to create distance 92 how much water? 78 painting around complex edges 88 painting folds and ruffles 95 painting leaves 96 painting lush greens 84 "puddle and pull" 100 reflective surfaces 104 run-backs 79 suggesting form with line 94 transparent surfaces 102

9 Floral Portraits Step by Step 106

Drawings for the demonstrations 122 Reference photos to paint from 128 The "One-Two-Threes" of Floral Painting 130

> CONCLUSION 133

> > INDEX 134

cluster blooms, p 91

painting leaves, p 96

step-by-step demos, p 106

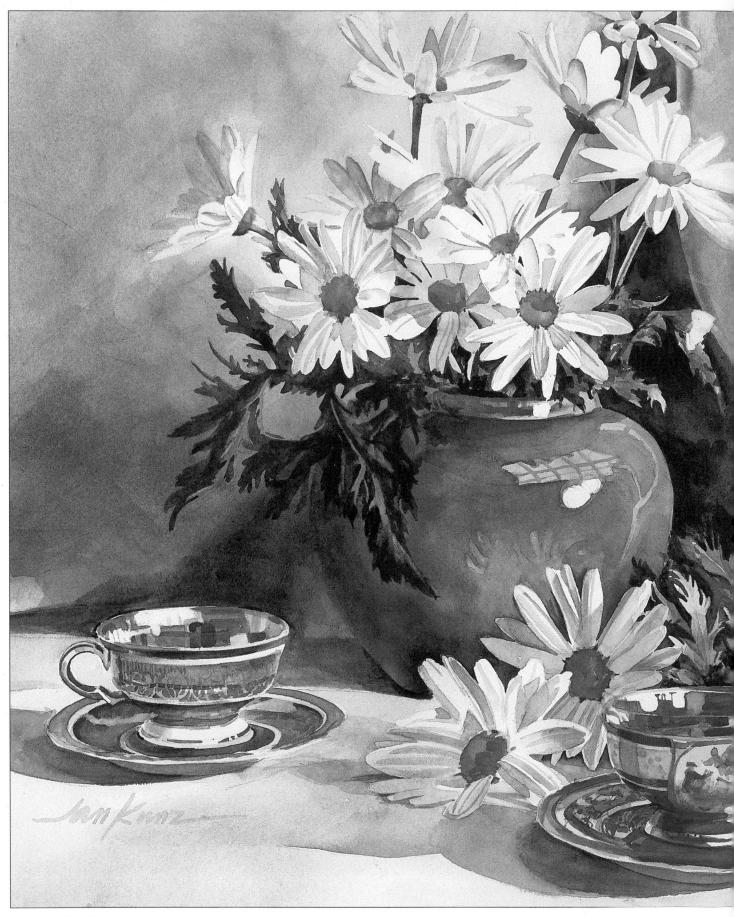

Daisies, 141/4" x18"

Introduction

Watercolor is great fun. Anything that will hold still long enough is liable to become the subject for a watercolor painting. Flowers are an almost perfect subject. They're incredibly beautiful, they stay quietly where you put them for a long period of time, and they don't offer suggestions or comment on your painting skill. You can paint beautiful florals even if you don't know a peony from a petunia.

That's the good news. Even better is the news that learning to really see the intricate forms and colors of the most simple blossoms will enhance your ability to see (and paint) everything!

Of course, it's not all a garden of roses. Painting flowers takes patience and concentration. You probably won't find the time to solve world problems, and now and then, you may even forget lunch!

I wish I could tell you there is a simple "one-two-three" method for painting flowers. As far as I know, there isn't one! Each new variety or floral arrangement presents a new challenge. Happily, there are a few constants. Flowers have similar folds, ruffles, convex and concave shapes. So, if you learn to paint a rounded surface on a lily, you can paint a rounded surface on a rose or any other flower. The colors may vary, but the technique is the same. For that reason I have included a section in this book describing how to paint many of the recurring shapes you'll encounter when painting flowers.

I know from experience that there are many of us who read the caption under the pictures and immediately begin to paint. However, those little paragraphs just won't hold all the information, so I hope you will read further! This book is filled with the basic techniques I have learned after years of painting for pleasure (and now and then for profit)!

There's a great deal of excitement ahead, so take the phone off the hook and let's get started.

lan Kunz

Important Things to Know Before You Paint

1

Bougainvilleas, 22"x30"

Jan Kunz

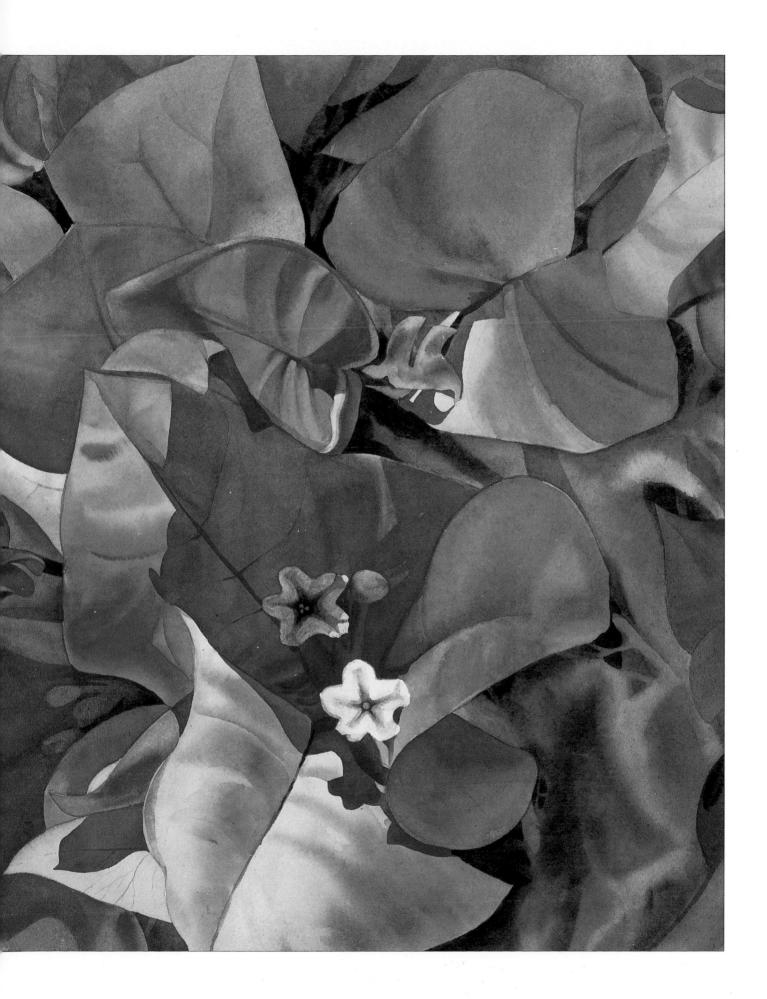

ost watercolor books have a section to help you select the tools and materials the author recommends. If you have as many books as I do, you are already well supplied. This section is aimed at the painter who is new to watercolor and needs to get outfitted. For those of you who have been painting for a while, you may not need new supplies, but I hope you will look at your palette and see that all the pigments, as well as the mixing areas, are clean.

BRUSHES

There was a time when the only good brushes were made of sable hair and were very expensive! Happily, that has changed, and there are many good synthetic brands on the market.

Select a brush that holds a good quantity of water and springs back into shape after each stroke. Most good art supply dealers will supply you with a cup of water with which to test a brush before purchase.

The size brush you choose should fit the job it is intended for. Just as you wouldn't paint a house with a trim brush, you shouldn't try to run a wash with a tiny brush or paint petals with a mop!

You don't need to have all of the brushes pictured. If you have a #14, 8 and 4 round and a 1" flat brush, you'll get along very well. The more you paint, the more brushes you'll collect. Remember that old saying about a craftsman being only as good as his tools? I think they were talking about watercolor brushes!

MODIFIED OIL BRUSHES

There will be times when you will want to scrub out an offensive

spot, lift a highlight or soften an edge. That is where modified oil brushes come in handy. Perhaps you can persuade an oil-painter friend to donate a couple of old bristle brushes to the cause.

I have modified two oil brushes for special use (as shown at right). The first is a flat #6 bristle brush I use along with an acetate frisket to lift highlights and make corrections. The tip of this brush is cut shorter to enhance its stiffness. The second brush is a round #2 bristle brush. I cut the tip of this brush at an angle to form a point, creating a great tool with which to lift small highlights.

I used to go to some trouble to modify brushes by wedging the bristles between heavy paper and cutting their tips with a utility knife. Since that time, I discovered it works just as well to wrap the bristles tightly with masking tape, and then cut them with scissors (or an X-Acto knife) right

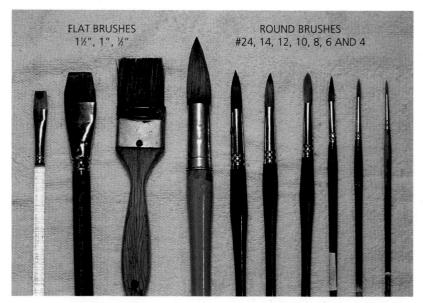

These are my brushes in the sizes I use most often. I'll admit they have a few years on them, but a good brush can be a good friend for a long time.

through the masking tape. The tape will come off easily after the surgery.

You can create a useful tool for drawing on damp paper by sharpening the handle of one of these brushes in a pencil sharpener.

One other oil brush (not pictured here) that I find useful is a flat #2 Grumbacher Erminette. It is small, only about ¹/₈" wide, and I use it to soften edges. This little brush is not too stiff and is very maneuverable.

PALETTE

The selection of a palette is largely a matter of personal choice, but it should have deep wells to hold the paint and large areas for mixing. I prefer a baked enamel palette. It does not stain readily, and my palette fits easily under the faucet for cleaning. I use a large 16"x11¼" butcher tray for mixing big washes.

PENCILS

In order to make graphite transfer paper (see pages 7 and 8) you will need a 4B or 6B graphite stick or one of those pencils that is entirely graphite, such as a Pentalic Woodless Pencil. For sketching in the field, I usually use an HB and a 4B. For preparing the drawing in the studio, I prefer an ordinary no. 2. Too hard a pencil scars the paper, and a soft one makes a thick line and dirties both the paper and your hand.

PAINT RAG

There is nothing like a good paint rag! You will hear that sponges, toilet paper or paper towels are just great, but here is one place I totally disagree! Sponges may pick up water from the brush, but they do little to wipe it clean when you want to dip into another color. Toilet paper gets soft and shredded and wets the table, and a paper towel is never where you need it. I prefer terry cloth bar towels. They are about 14" to 16" square; you can buy them from a restaurant supply house or by the pound from a laundry after they are too old for commercial use. These towels are rugged and clean up easily in the washing machine.

I begin each painting with a clean rag placed on my drawing table next to my palette. Often two or three clean rags are used during the course of one painting.

FACIAL TISSUES

It is difficult to paint without facial tissues. You need them to

brushes for lifting highlights and making corrections, trim the tips along the dotted lines.

To modify these

Wrap the tip of an oil brush with masking tape and trim it with scissors to make a useful clean-up tool.

wipe out the palette, pick up a spill or remove a misplaced color.

KNIFE

An X-Acto knife or razor blade is a useful tool to make an acetate frisket or pick out a highlight.

LIQUID FRISKET

Liquid frisket is used to mask areas you want to protect when applying washes of color. I use it sparingly because the edges appear hard after it is removed. However, there are times when painting around objects is simply impractical, and nothing else will do as well.

Liquid frisket is sold at most art stores. Winsor & Newton calls theirs Art Masking Fluid, and Grumbacher's brand is Misket. Liquid frisket can ruin your brush if you aren't careful to use it according to the directions on the bottle.

Place frosted acetate over the painting and outline the area you wish to lift.

Move the acetate to a piece of cardboard or thick paper, and cut out the shape you have outlined.

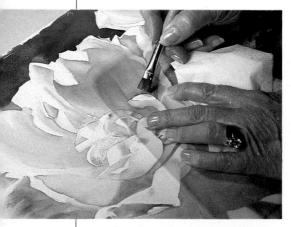

Re-place the acetate into position over the painting and remove the offending area with a damp, stiff brush.

FROSTED ACETATE

Frosted, or matte, acetate (depending on the brand name) sheets are translucent, and the surface readily accepts pen or pencil. The acetate sheets should be thick enough to withstand handling (0.005 or 0.007 is best). Some of my students have had difficulty in obtaining frosted acetate, but your art supply dealer can get it for you. The brands I use are Grafix Acetate or Pro/Art. These come in a tablet of 9"x12" sheets. Be sure you don't buy clear acetate-it's too smooth to accept the pencil.

You will find many uses for frosted acetate. Its nearly transparent quality makes it possible to draw on several pieces and then superimpose them on one another to create a composition.

You can make an acetate frisket for use in lifting color from small areas. Just place the acetate over the painting and use a pencil to outline the area to be lifted. Remove the acetate and carefully cut out the outlined shape with an X-Acto knife. Next, re-place the acetate frisket over the painting and remove the offending area with a moistened stiff brush (like the modified oil brush). Corrections of this kind nearly defy detection, but they should be used only when the painting is near completion. Stiff brushing can distress the paper to the point that it will not accept more pigment well.

WATERCOLOR PAPER

Many watercolor instructors urge beginning painters to work on

good quality watercolor paper, and I agree. If all you want to do is practice brushstrokes, why not use old newspaper want ads? Even experienced watercolorists have real problems with poor, unwieldy paper.

What is a good watercolor paper? If you don't know how to judge good paper, start with a brand name that is recognized by artists as being top quality. The best paper is 100 percent rag, hand- or mold-made. Some of the top brands include Arches, Holbein, Fabriano, Winsor & Newton, and Strathmore watercolor board.

Most papers come in three surfaces: hot press (smooth), cold press (medium) and rough. In addition, watercolor paper comes in various weights. The most popular are 140-lb. and 300-lb. (The weight refers to the weight of 500 sheets.) A standard-size sheet is 22"x30". You can also purchase larger (elephant-size) sheets, or buy it by the roll. For the demonstrations in this book, I used 140-lb. or 300-lb. Arches cold press paper.

STRETCHING PAPER

Stretching paper prevents it from buckling once water is applied. If you use 140-lb. paper I recommend that you stretch it. There's enough to think about while you are painting without worrying about wrinkled paper. Stretching isn't required for 300-lb. paper.

Stretching paper is easy. Have everything ready beforehand because you don't want the paper to begin to dry while you are working with it. You will need a drawing board slightly larger than the paper. Basswood, "foamcore" or "gator" board all work well. You will also need a filled staple gun. I use a regular desk stapler, but if your board is extremely hard, you may need the heavier industrial type.

Fill a large container with cool water. You can use a sink or bathtub. Place the paper into the water. If it doesn't fit, make it into a soft roll. After about two to five minutes (and when you are sure the entire paper is thoroughly wet), remove the paper and place it down flat onto your drawing board. Immediately begin to staple all around the edge, placing a staple about every two to four inches. Paper exerts a great deal of pull as it dries, so be sure the staples are well in place. I roll a clean terry cloth towel over the surface of the paper to pick up excess water and speed drying. It is necessary that you lay the drawing board on a horizontal surface to dry. You don't want the water to run to one side and cause a buckle.

TRANSFER PAPER

Flowers have many complicated shapes, so I like to do my planning on tracing paper, as you will soon see. Once I am satisfied with the drawing, I transfer it onto the watercolor paper. I have never found a commercial transfer paper I like as well as the graphite one I make myself. When you use the paper you make yourself, it is almost like drawing directly onto the watercolor paper. Commercial papers sometimes leave a line you cannot erase, as well as a white margin on either side that repels the paint.

To make graphite transfer paper, you need a piece of good quality tracing paper cut to almost any size. Make it large enough so you can use it again and again with various size drawings. Mine is about 18" square.

Rub one side of the paper with a soft graphite stick or woodless pencil until it is pretty well covered. A crisscross motion works very well. Once this is accomplished, dampen a piece of facial tissue with lighter fluid or rubber cement thinner, and using a circular motion, rub over the blackened surface. The graphite will smear at first, but keep rubbing until the surface takes on a more or less uniform value (see page 8). When the transfer paper is finished, I sometimes bind the edges with Scotch tape to keep the paper from tearing after repeated use.

Before you use your new transfer paper, be sure you have shaken or dusted all the excess graphite from the surface to prevent it from soiling your watercolor paper.

Use it just as you would any other transfer paper. Put it beneath your drawing graphite side down, and trace your drawing onto the watercolor paper.

Have your paper, drawing board and filled staple gun ready before you begin.

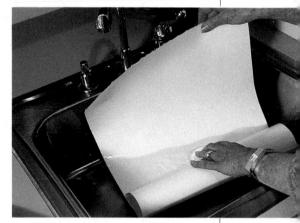

If your paper is too large to fit into the sink, make it into a soft roll and gently submerge it. Be careful not to fold or scar the paper. Hold it under water until every part is thoroughly wet.

7

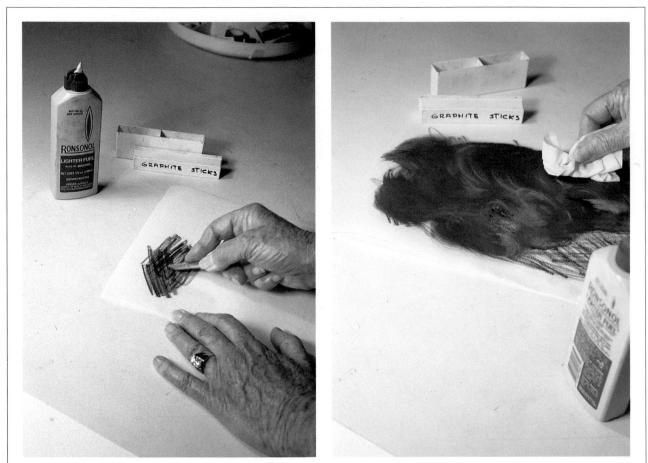

With a graphite stick or soft lead pencil, scribble lines back and forth onto a piece of good-quality tracing paper.

Use a piece of facial tissue moistened with lighter fluid or rubber cement thinner to rub the lines together.

PAINT

In this book we will be working with transparent watercolors. The pigments that come in tubes are easiest to work with. You can squeeze out a fresh amount when you begin a painting, and the soft consistency makes it easy to use.

Many people consider all water-based paint to be watercolor, including acrylic, tempera or gouache. Be careful to get transparent *watercolor*. The label will read something like "water colors artists' quality," "artists' water colour" or "professional artists' watercolor," depending on the brand. There are many good brands of watercolor pigments. The wellknown names include Winsor & Newton, Grumbacher, Holbein and Liquitex. The color may vary slightly between different brands, but the quality remains consistently high.

How the pigments are arranged on your palette will vary. My rectangular palette has warm colors on one side, and cool on the other side. If you are happy with the way your palette is arranged, stay with it. The arrangement isn't nearly as important as knowing where a pigment is located. You don't want to stop and look around the palette for a special color while the wash is drying!

PAINTING TIPS

You can't have painted as long as I have and not come up with some definite opinions. So, at the expense of sounding like your mother, here is some advice.

It may seem like a trivial thing, but a well-organized work space can help you work more efficiently. When painting, your entire concentration should be on the painting itself. By the time you put brush to paper, everything else should be in order. A clean paint rag should be positioned

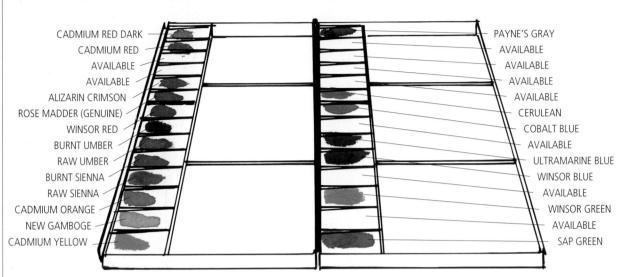

These are the colors I keep on my palette. The available spaces are used when I want to add a special color for a particular painting, such as Rose dore, phthalo red, Winsor violet or cobalt violet, or Hooker's green dark, Prussian blue, Antwerp blue or manganese blue. I do not own a tube of black pigment.

next to your palette for immediate use. The water bucket should be large and full of clean water. All the brushes you might need should be placed for easy access (I use a jar or carrousel), and facial tissue should be within reach.

Clean Your Palette and Paint

Palettes get dirty, so most of us wipe them out frequently. When cleaning your palette, don't overlook the pigment. Color is transferred from pigment to pigment during the painting process, and colors can lose their brilliance. I like to take my palette to the sink and run a gentle stream of cool water directly onto the pigments. Then, using one of my small brushes, I gently remove any color that doesn't belong. Next, I give the palette a quick shake to remove excess water and wipe it dry. I'm very careful if the pigment is fresh. Even at that, very little pigment is lost, and what is

left is fresh and brilliant.

Small Cautions That Can Help

Keeping the water container filled to the top will prevent missing the water altogether. It's easier than you think to bring a dry or dirty brush to the paper! Use a clean paint rag and replace it as necessary. In my estimation, sponges, paper towels and toilet paper make poor substitutes.

Most Important Tip

Don't listen to any of this advice if it doesn't sound right for you. That goes for any other advice you may have heard. Watercolor painting is a very personal experience. You are in charge. Have faith in your own ability to know what works for you.

I use a gentle stream of water to clean my palette and the pigments during the painting process.

A well-organized work space can make painting easier. Your paint rag, water and facial tissue should always be within easy reach.

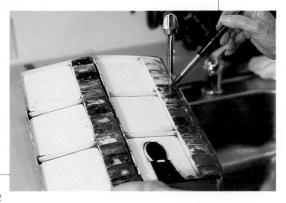

About Color and Watercolor Paints

2

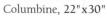

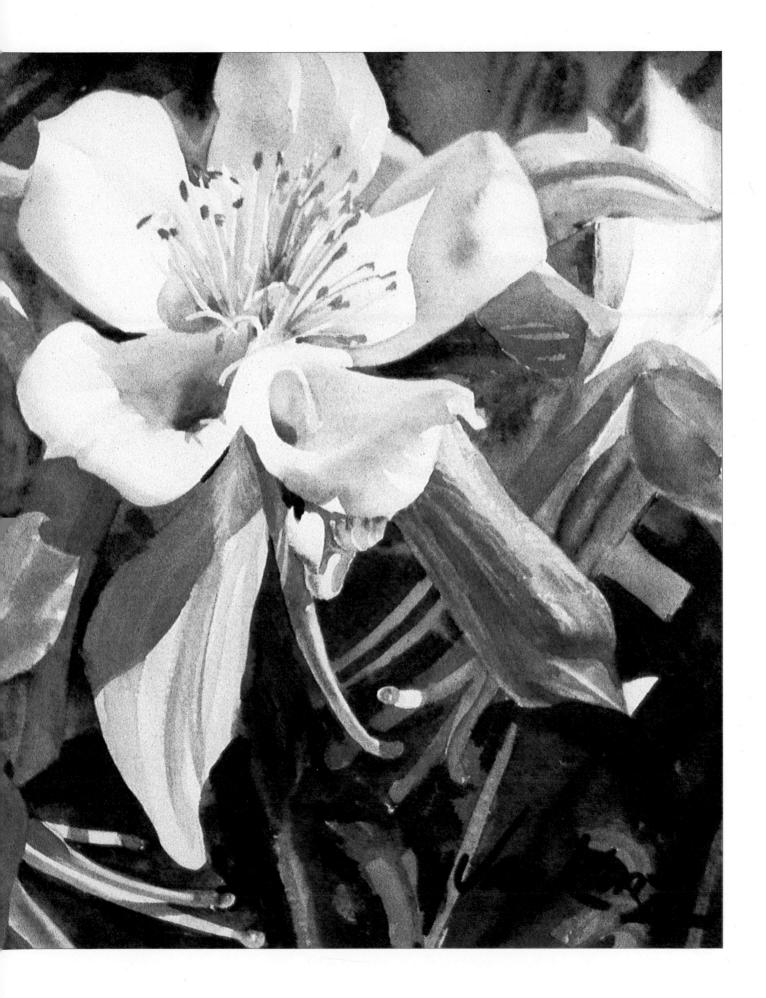

olor is a highly personal element, and learning to use it effectively is a hands-on process. It would be worth your while to learn all you can about color; make use of the many fine books available on color and color theory. What you'll read here is a simplified version of what I have learned over the past twenty years through study and experience.

Although some of this material may seem rather basic, perhaps this quick review will remind you of some things long forgotten. Anyway, like chicken soup, "it can't hurt!" If you are new to painting or are unsure about color, this is information you need.

WHAT IS COLOR?

We sense color when our eyes are struck by light waves of varying length. Our eyes pick up these waves and translate them as light. If there is no light, there is no sight, as you know if you have ever experienced total darkness. Even though we call it "white light," the light that comes from the sun contains all the colors we see around us. Every colored object we see contains *pigments* that have the ability to absorb certain rays of color and reflect others. For example, a banana is yellow because the pigment in its skin reflects only the yellow light we see and absorbs all the other colors.

Through the years, some materials have been found to be especially rich in pigment. These are the materials that are purified and made into the paints we use.

Hue

Hue is the term used to name a color. Red, green, yellow and blue are hues. It has nothing to do with whether the color is intense or pale, dark or light.

Primary Colors

The primary colors are red, yellow and blue. These colors cannot be made with a combination of any other pigments.

Secondary Colors

Secondary colors are those colors we can make by mixing the primary hues. Each secondary is a combination of the primaries on both sides of it. Red and blue make purple. Red and yellow make orange. Blue and yellow make green. All the other colors are some mixture of the three

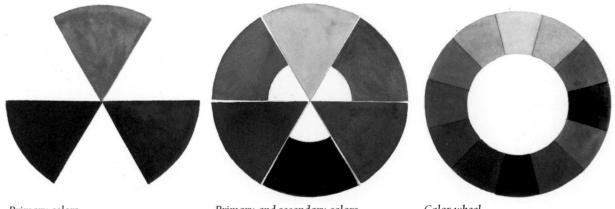

Primary colors

Primary and secondary colors

Color wheel

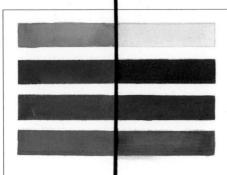

Warm and cool versions of the same hue

primaries and three secondary colors.

Complementary Colors

When we place the primary and secondary colors equidistant from one another and then fill in the spaces by mixing adjacent colors, we will have created a color wheel. The colors located opposite one another are called *complementary colors*. Red and green, yellow and purple are examples of complementary colors. When complementary colors are mixed, the result is a neutral gray. Complementary colors, in dark values, are almost always muddy.

Warm and Cool Colors

When we speak of warm and cool colors, we are talking about color *temperature*, not about value or color intensity.

Many of the pigments we use in watercolor have warm and cool versions of the same color. Alizarin crimson is a cooler red than cadmium red, for example. The colors on the left of the chart (above) are somewhat warmer than those on the right. If you are in doubt about the color temperature of the pigments on your palette, consult the pigment chart on pages 16-17.

Value

Value refers to the lightness or darkness of a color. Different pigments have different value ranges. *Value range* refers to the number of intermediate values you can get by using a color directly from the tube (darkest value) and then adding water until it becomes a faint tint. In the examples at right, yellow, at its darkest, has only a short value range. Alizarin crimson, on the other hand, has a very long value range. Cobalt blue's value range is somewhere between the two.

WATERCOLOR PIGMENTS

We can assume most professional watercolor pigments are permanent and chemically stable. Certainly, they are as enduring as oil pigments. Watercolors do have unique qualities that we need to understand.

Opaque and Transparent Pigments

You don't have to work with watercolor very long to become

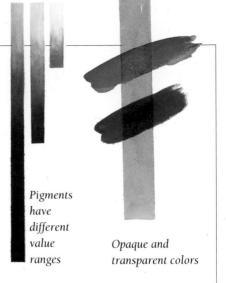

aware that there are two kinds of watercolor pigments. Some pigments display a fair degree of opacity while others are extremely transparent.

Think of *opaque* (or *precipitat-ing*) colors as being little microscopic granules of pigment. When we paint with opaque colors, these little chunks of pigment remain deposited on the surface of the watercolor paper. When light is returned from an opaque color, it reflects only from the pigment granules.

Transparent (or *staining*) colors are more luminous than opaque ones. The reason is that light rays penetrate the thin film of transparent pigment and reflect the white paper beneath.

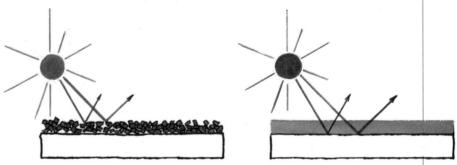

Light bounces off color granules of opaque pigments, but light reflects the white paper beneath transparent pigments.

MIXING BRILLIANT DARK VALUES

If ever clean, beautiful colors were important, they are important when you paint flowers! If we are to create the illusion of sunshine in our painting, we must observe the 40 percent rule explained in Chapter 7. According to this rule, the shadow side (if no reflected light is present) and the cast shadows must be a full 40 percent darker than the sunlit side. In other words, on a value scale gradated from value 1 (white) to value 10 (black), the shadow side must be a full four values darker than the sunlit side. With long-range pigment, we have nothing to worry about. For example, to paint a green box whose sunny side is value 5, use Winsor green for both the sunny side and the shadow sides. The problem arises with colors such as yellow or orange. These are not dark enough, even right out of the tube, to paint the shadow sides of objects.

The question is: How can we mix a brilliant, dark value of a color with a short value range? The answer is to mix it with a color having a long value range from the *same* side of the color wheel.

To help you see this more clearly, I have divided the color wheel (above right) in half. This division, falling between yellowgreen and yellow at the top and violet and red-violet at the bottom, separates the warm and cool colors.

The colors that are located close to one another are harmo-

To paint high-contrast subjects in bright sunlight like the one above, you will need to mix dark values of colors that have a short value range, such as yellow. You can keep these darks brilliant (avoiding mud) by mixing them with darker colors from the same side of the color wheel, rather than with a complement from the opposite side of the wheel.

nious because each color contains some of the color lying next to it. The colors near the bottom of the color wheel are darker in value than those near the top.

Your mixtures will remain brilliant as long as you combine colors from only *one side* of the color wheel. Select a pigment from the opposite side and you will have mixed a "gray."

It's true that many fine artists are known for using beautiful grays in their paintings. Grays can be wonderful in light and middle values. You can get into trouble, however, if you use neutral grays in dark values, especially over a large area of your painting.

Remember, mixing complementary colors in values darker than 6 equals mud!

COLOR SENSE

The selection of the color scheme and the palette we use will be largely determined by the flowers we wish to portray.

WARM

COLORS

As you gain experience, you will use fewer hues, but you will take advantage of color differences that can be created by variations of color temperature, value and intensity.

As you will see in the demonstrations to follow, it is important to give life to whatever color you use by making it "move." This means you must avoid painting a solid color and value from side to side and up and down any area if you are to avoid a poster look.

Here is some advice that, I believe, will serve you well: Save pure yellow for the foreground (yellow objects in the distance are yellow-green or yellow-orange). Keep the number of hues to a minimum. Remember, always put a little warm in the cool areas and a little cool in the warm areas!

COOL COLORS

PIGMENT CHART

Most watercolor pigments fit into one of four groups:

- 1. High-intensity opaques
- 2. Low-intensity opaques
- 3. Low-intensity transparents
- 4. High-intensity transparents

The following chart will help you compare various watercolor pigments. The notation under *Similar Color Comparison* (SCC) will tell you whether a pigment is warm or cool when compared to another pigment of the same hue. For example, French ultramarine blue's SCC notation will be *W*, because it is a warm blue when compared to Indigo blue, whose SCC is *C* to show it is a cool blue. *M* indicates the color is midway between warm and cool; it is a pure hue. Some colors were left blank because I know of no comparable pigments from a tube.

Although some of the pigments in Groups 2 and 3 have very long value ranges, they will appear muddy and lifeless if used singly in dark values. Mix these colors with a long-range transparent from the same side of the color wheel.

PROPERTIES of WATERCOLOR PIGMENTS

Pigment	Warm/ Cool	Similar Color Comparison	Darkest Value	Opaque	Paper Staining	Transparent	Black Content
High-Intensity Opaques						2	
Cadmium Yellow	W	W	2+	Very	Slight	No	None
Cadmium Orange	W		3+	Very	Slight	No	None
Cadmium Red	W	W	4+	Very	Slight	No	None
Vermilion	W	W	4+	Yes	Slight	No	None
Cerulean Blue	С	С	4+	Very	Slight	No	None
Cobalt Blue	С	М	5+	Yes	Slight	No	None
Low-Intensity Opaques	-						
Yellow Ochre	W	W	3+	Yes	Slight	No	Slight
Raw Sienna	W	W	4+	Yes	Medium	No	Slight
Raw Umber	W	С	6+	Yes	Slight	No	High
Burnt Sienna	W		6+	Partly	Medium	Slightly	Slight
Burnt Umber	W		8+	Yes	Slight	No	High
Low-Intensity Transpar	ents						
Brown Madder (Alizarin)	W		8+	No	High	Yes	Medium
Indigo	С	С	9+	No	High	Yes	Medium
Payne's Gray	С		10+	No	Medium	Yes	Medium
Sap Green	С	W	6+	No	High	Yes	Medium
High-Intensity Transpar	rents	e					
New Gamboge	W	С	2+	No	Slight	Yes	None
Winsor Red	W	М	5+	Slightly	Medium	Yes	None
Alizarin Crimson	W	С	8+	No	High	Yes	None
Winsor Blue	С	С	10+	No	High	Yes	None
Winsor Green	С	С	10+	No	High	Yes	None
French Ultramarine Blue	С	W	8+	Slightly	Nearly	No	None

About Color and Watercolor Paints

GROUP 1: HIGH-INTENSITY OPAQUES

These opaque pigments have very short value ranges. They are useful for over-painting or for bright accents.

Vermilion Vermilion is a beautiful, brilliant (toward orange) red. It is more brilliant than cadmium red and a good deal more expensive.

Cadmium Orange A pure opaque orange. I use it alone or mixed with various reds to add brilliance. Mixed with Winsor blue or green, the result is a rich, grayed green.

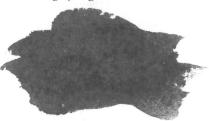

Cerulean Blue This is a heavy, chalky pigment. Used next to ultramarine blue or Winsor blue, it suggests reflected light. Next to rose madder, it becomes a cool accent.

Cadmium Red This brilliant, glowing red dries considerably lighter than you might suspect. The pigment is opaque and heavy; therefore, it can easily be moved about in a puddle of water.

Cobalt Blue This blue has many uses. A slightly opaque pigment, it is used to "glaze back" an overly demanding area. Combined with other pigments, it makes beautiful secondary colors.

GROUP 2: LOW-INTENSITY OPAQUES

These pigments have varying value ranges. They contain black, and used singly in dark values, tend to appear lifeless and dull.

Yellow Ochre I use yellow ochre very seldom. It is a grayed yellow, and I find it somewhat greasy. Mixed with red, it produces a grayed orange.

Burnt Sienna A grayed, versatile orange that can create beautiful grays. Used alone in small areas, it suggests rust spots on flowers or burnt leaves.

Raw Sienna I use it with green or blue to produce a grayed green in light values. Used alone, or next to burnt sienna, it can suggest the edge of old leaves.

Burnt Umber This warm brown should never be used singly in dark values, but mixed with alizarin crimson, it makes a wonderful near-black for crevices.

Raw Umber This is a dark, almost greenish yellow. I like to use a touch of this color with Winsor blue to suggest cool, grayed shadows.

GROUP 3: LOW-INTENSITY TRANSPARENTS

These colors have long value ranges, but like the low-intensity opaque colors, they contain black. If used alone in values darker than 6, these colors will appear flat and lifeless.

Brown Madder (Alizarin) This is a beautiful, rich red-brown. Combined with new gamboge, it makes a brilliant substitute for burnt sienna. I sometimes like to "charge" this color into other reds.

Indigo A blue-black "garlic" pigment a little goes a long way. This pigment and Payne's gray (right) have a place on my palette, but I find little use for either of them in floral painting.

Payne's Gray A cold gray. I try to avoid this color because it can become too convenient. Overuse can result in gray paintings.

Sap Green An intense (toward orange) green. I like this color combined with a sienna for grayed green and with Winsor blue or green. It is hard to handle and will stain the paper, so use it with care!

GROUP 4: HIGH-INTENSITY TRANSPARENTS

These brilliant pigments remain luminous at all value levels. Unlike those in Groups 2 and 3, they contain no black. The pigments in this group can combine with any other to achieve lively, dark values.

New Gamboge This is a clean, brilliant yellow. (Don't confuse this color with gamboge, which is dull by comparison.) It can be used to suggest reflected light. It mixes well to make brilliant secondaries.

beautiful foliage colors.

tends to dominate. It's useful in mixing

Winsor Red This powerful red is less transparent than other pigments in this group. I ase it singly or with other reds to intensify their color. Mixed with new gamboge, it makes a brilliant orange.

Winsor Green An intense, cool green. Like Winsor blue, this color can combine with others to create beautiful foliage. It's also known as Thalo or phthalocyanine green.

Alizarin Crimson This cool, versatile red is my favorite. It has a very long value range and can extend the range of other pigments. Also, it mixes to make beautiful secondaries. This is probably the most-used pigment on my palette.

French Ultramarine Blue This warm blue can be considered transparent or opaque depending on how it's used. Mixed with alizarin crimson, it makes a wonderful violet. With burnt sienna, it makes a beautiful gray.

Anatomy of Flowers Simplified

3

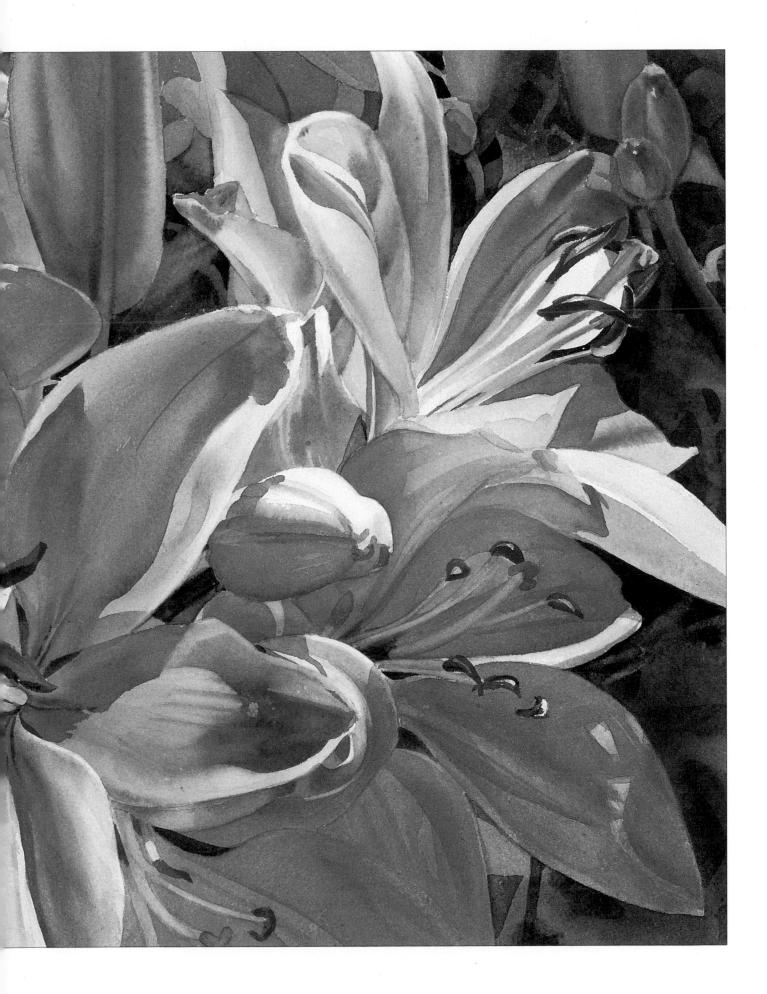

natomy may sound like a strange word to show up in a book on floral painting. Watercolor florals are a natural subject for splash and color, but to paint them convincingly we need to know how flowers are put together and a great deal more.

The purpose of this chapter is to heighten your awareness of the form, color, texture and growth patterns of the flowers you paint. Whether your goal is a detailed portrait of flowers, or a loose interpretation of their form and brilliance, the better you know your subject, the better chance you have for a successful painting.

PARTS OF A FLOWER

From an artist's point of view, a flower's anatomy is made up of basic forms. Form, or shape, is important because we humans see only shapes, values, edges and color. Shape identifies the object. The chief differences between a beginner and a skilled artist are the awareness of subtle differences between shapes and the ability to transfer them to the paper. Flowers possess many shapes, and we must train ourselves to see them. Value and edges further identify objects and add detail and interest.

Before we get to the nitty-gritty of drawing flowers, there are a few terms you should know. As you may remember from high school biology class, flower parts have names, so rather than direct you to "that little thing sticking up in the middle" (below), I've provided a diagram of the flower's parts. I promise this is as technical as we will get!

FILAMENT

STYLE

SHAPE

Flowers, along with everything else in nature, have three dimensions. Therefore, if you want your flowers to look lifelike, you have to create the illusion of three dimensions in your paintings. Every object in the composition, including the table upon which the flowers rest and the vase in which they are placed, must look as if it has room to exist in space. I want you to see how important it is to create this illusion of depth. Let's begin with a vase that could be used in a floral arrangement.

In the photograph, it takes two hands to hold the vase. It's heavy, and there is no doubt it's a solid, three-dimensional form. In contrast, the silhouette has the same shape as the vase, but it looks flat and is obviously not real. The

ANTHER

STIGMA

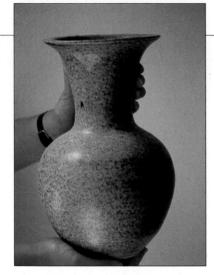

There is no doubt the vase pictured here is a three-dimensional form.

outline drawing also looks unreal. The lack of depth makes it impossible to mistake either of them for a real vase.

You can see how important it is to know how to draw objects so they appear to exist in space. Probably the best way to accomplish this illusion of three-dimensional forms is to "construct" objects as you draw them. Think of all of the objects in your composition as being transparent. As you draw each object, let the lines follow around the back and the sides. In this way you can see that every element in your drawing has depth in space. Not only will you create the illusion of reality, but you will be better able to avoid the appearance of two different objects occupying the same space. You will create an illusion of a solid form in space.

Before you decide to give up painting flowers and take up something easy like brain surgery, let me assure you, constructing objects as you draw them isn't as difficult as it may seem.

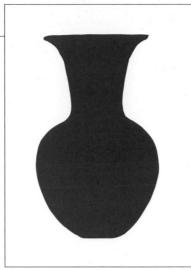

This silhouette looks flat, and you would not mistake it for a real vase.

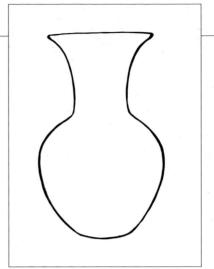

The lack of depth in this line drawing gives no illusion of reality.

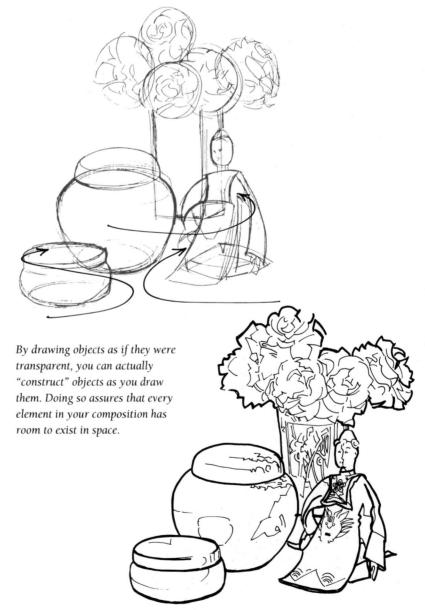

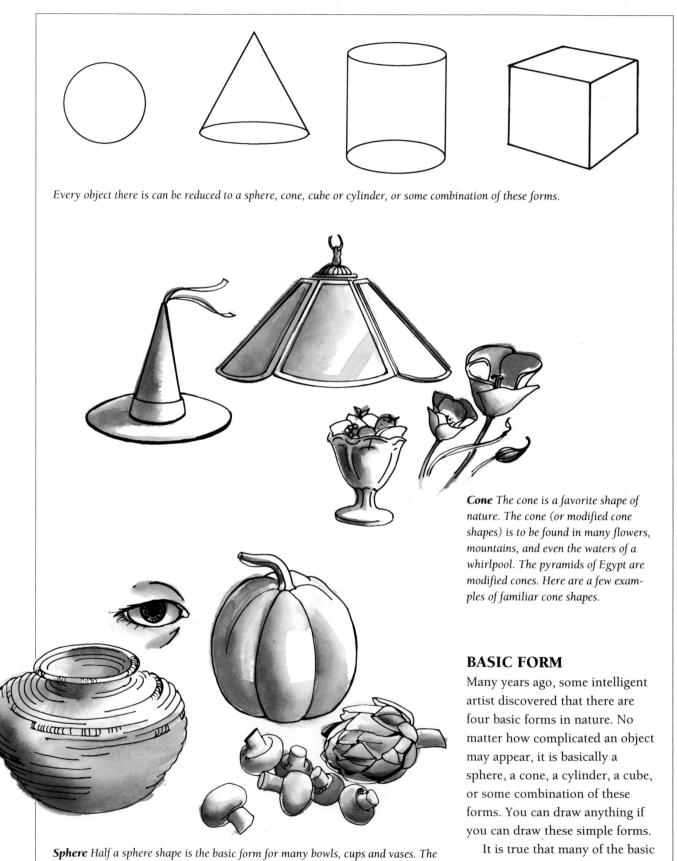

shape of many fruits and vegetables is basically spherical. I always begin drawing the human eye by first constructing a sphere.

forms as they appear in nature

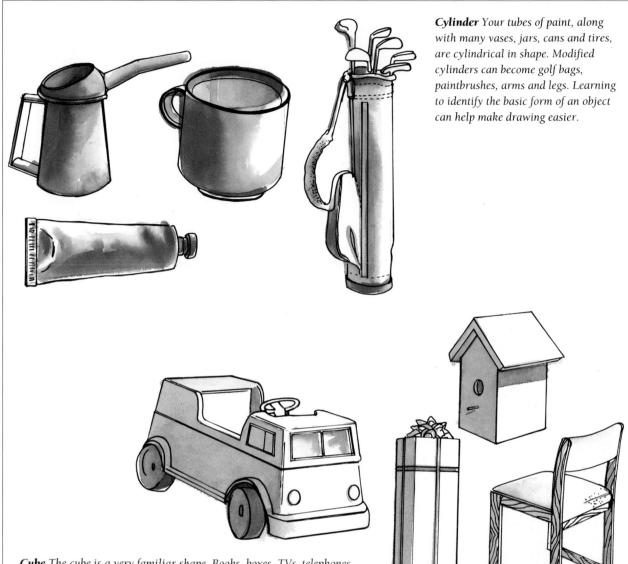

Cube The cube is a very familiar shape. Books, boxes, TVs, telephones, toys and many other objects are cubes or modified cubes. You are probably sitting on a cube right now!

aren't perfect. A banana is cylindrical in shape, but it is rather flat on the sides and turns up at the ends. An apple can be thought of as spherical, but the shape has soft edges and is somewhat elongated. Nevertheless, once you get the basic form down on paper, your drawing will be well on the way to satisfactory completion.

Try to get into the habit of recognizing the basic forms of the

objects you draw before you turn your attention to any detail. Once you've identified the overall outer shapes, be sure to be equally careful with the internal shapes that describe a particular object.

Looking for Basic Form in Flowers

In the illustrations on the following pages, I began each drawing by establishing the basic form of the flower. No matter how much detail was added, the underlying structure is still visible. In paintings shown in later chapters, you will see that we can eliminate much of the detail and *still* create beautiful flowers as long as the basic shapes are maintained.

Flowers With Simple Forms

DISK-SHAPED FLOWERS

Daisies and similar flowers are shaped like a disk or thin slice of a cylinder. Viewed straight on, these flowers are circular with petals that radiate from the center. Color, shape and size of the petals vary depending on the specimen.

Viewed from an angle, the shape is elliptical. The diskshaped flowers in this illustration are modified to represent daisies.

In laying out these sketches, I drew the forms freely. The purpose of these drawings is to plan the overall shapes, locate the stems, and determine the placement of each blossom. A daisy is formed like a disk or a thin slice of a cylinder. I use cylindrical shapes to help place the daisies. The stems are long, slender cylinders and appear to be emanating from the center of each disk shape. Notice that the partly opened blossoms are sketched as modified cones. Seeing objects as basic forms makes them easier to draw.

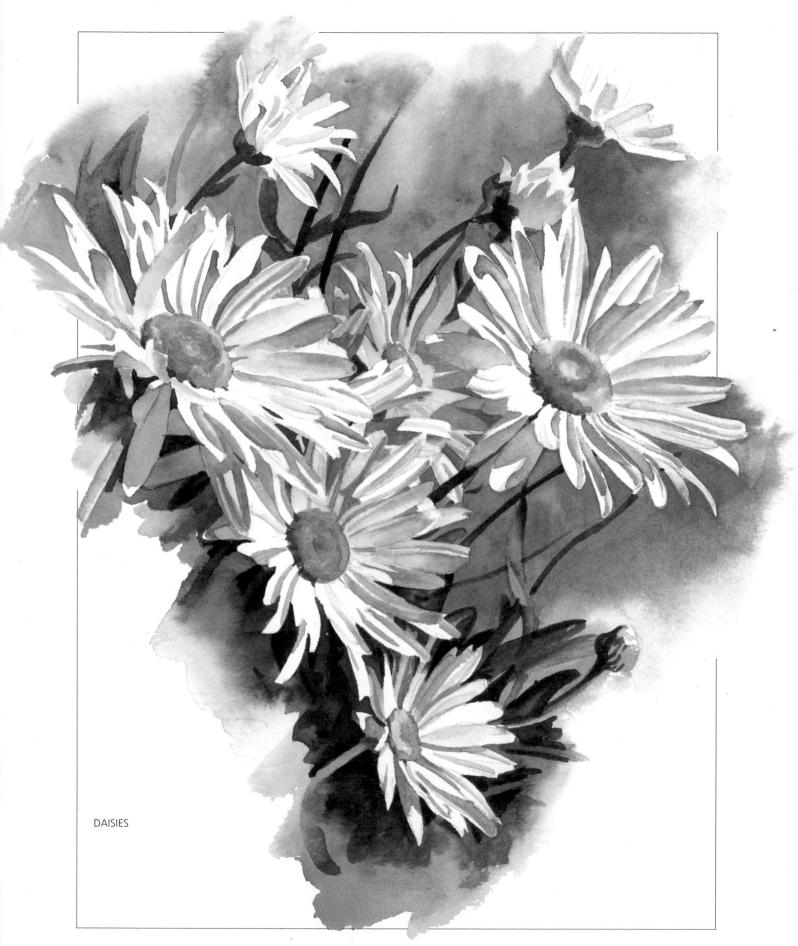

Anatomy of Flowers Simplified

SPHERE-SHAPED FLOWERS

Many flowers have spherical shapes. Thistle, roses and peonies are three examples. To paint these flowers, begin with a sphere. The particular variety of flower is of secondary importance.

In this illustration, notice that the emphasis is on the sphere shape. Sure, I had fun painting all the petals to make it look complicated. However, every brushstroke was intended to enhance the feeling of roundness.

> Peonies are sphere shaped. I swing my arm to inscribe large circles. Obviously, none of these forms are perfectly shaped, but most shapes in nature are not geometrically perfect. Nonetheless, there is a feeling of roundness.

Painting Watercolor Florals That Glow

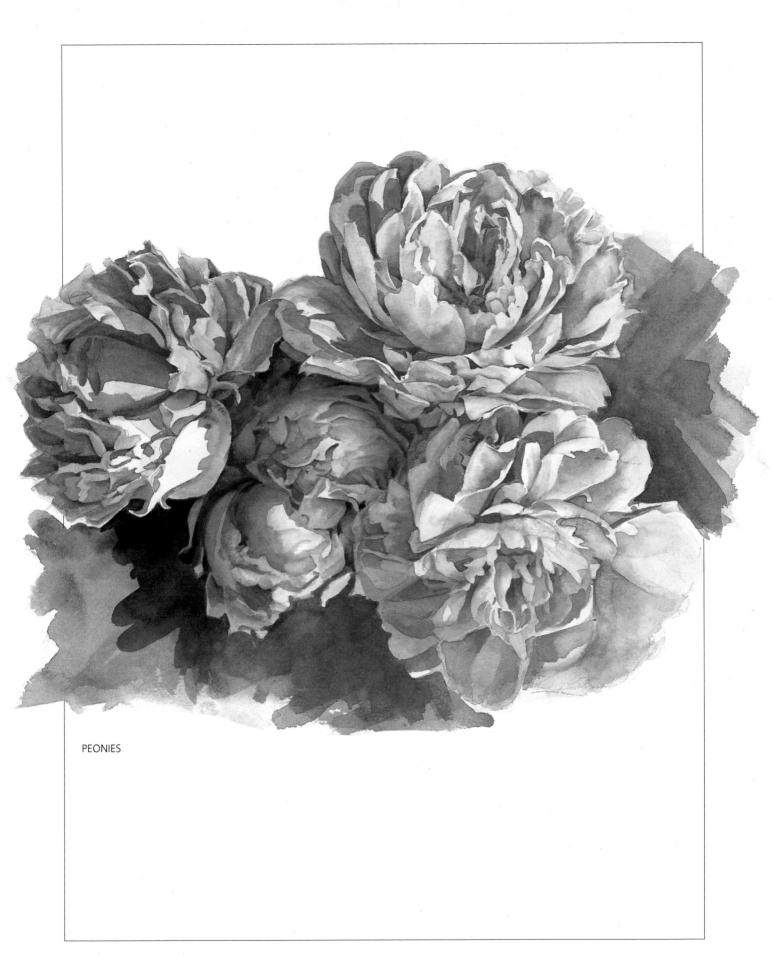

CONE-SHAPED FLOWERS

The cone shape is very common among flowers. Lilies, fox glove, lilacs, larkspur and many others are basically shaped like a cone. Some flowers, such as rhododendrons and hyacinths, have individual cone-shaped flowers, but their blooms are composed of several individuals. The collection of individual blooms forms a sphere or a cylinder.

轨

The fox glove bloom is a collection of bell- or cone-shaped blossoms growing on a single cylindrical stem. Once the basic form is established, it is an easy job to suggest a field of these beautiful wildflowers with simple cone shapes.

Painting Watercolor Florals That Glow

OX GLOVE

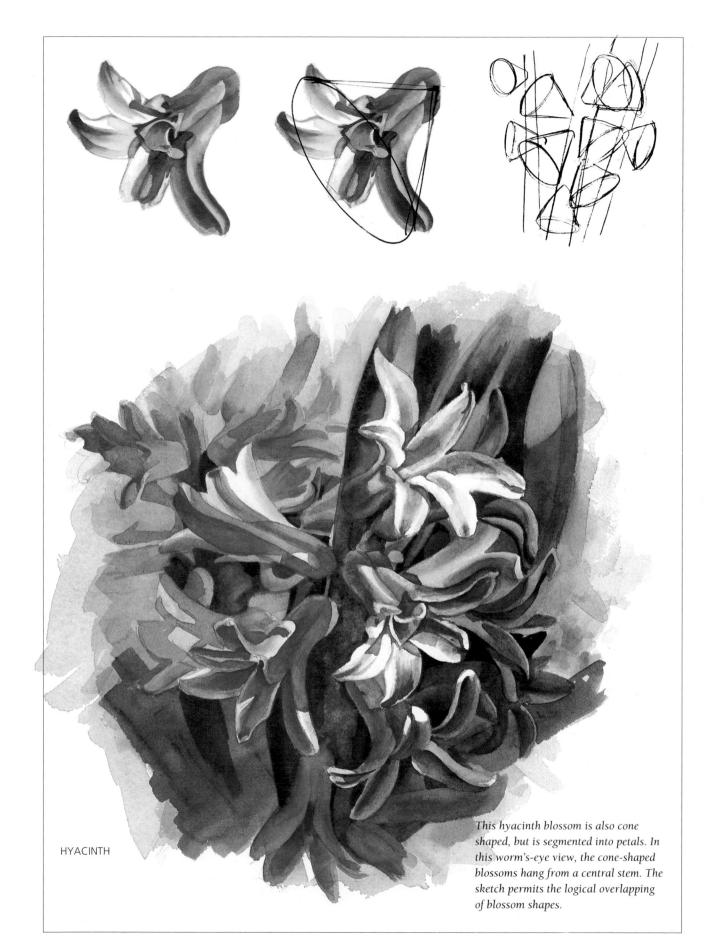

Multi-Shaped Flowers

CYLINDER AND DISK

Most flowers are made up of a *combination* of basic forms. Once you begin to think about basic forms, you will have little trouble recognizing them in every flower you draw. Daffodils are formed of a small cylinder occupying the center of a larger disk.

The shape of a daffodil is that of a cylinder placed on top of a disk. The base is wide and disk shaped (or a thin slice of a cylinder). The top cylinder is somewhat long but with a smaller diameter.

Painting Watercolor Florals That Glow

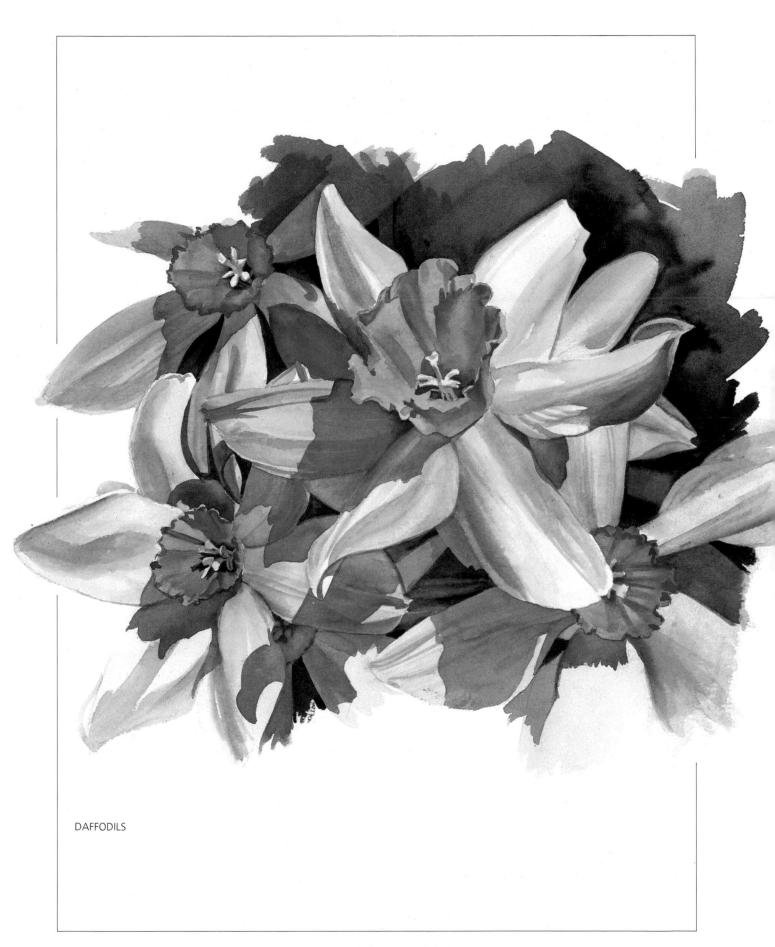

TWO SPHERES

Irises are also a combination of shapes. I see them as two spheres. The top portion of the flower, whose petals curl up toward the center, encases the smaller of the spheres. The larger, bottom sphere is composed of petals bending back to encircle the stem.

Now you have the idea. Think basic form. Paint any flower you choose, but think basic form first! It has been said that form drawing is fundamental to all art. Become aware of the objects you draw as solid forms having depth.

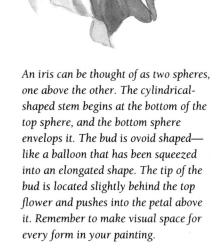

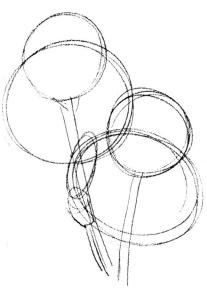

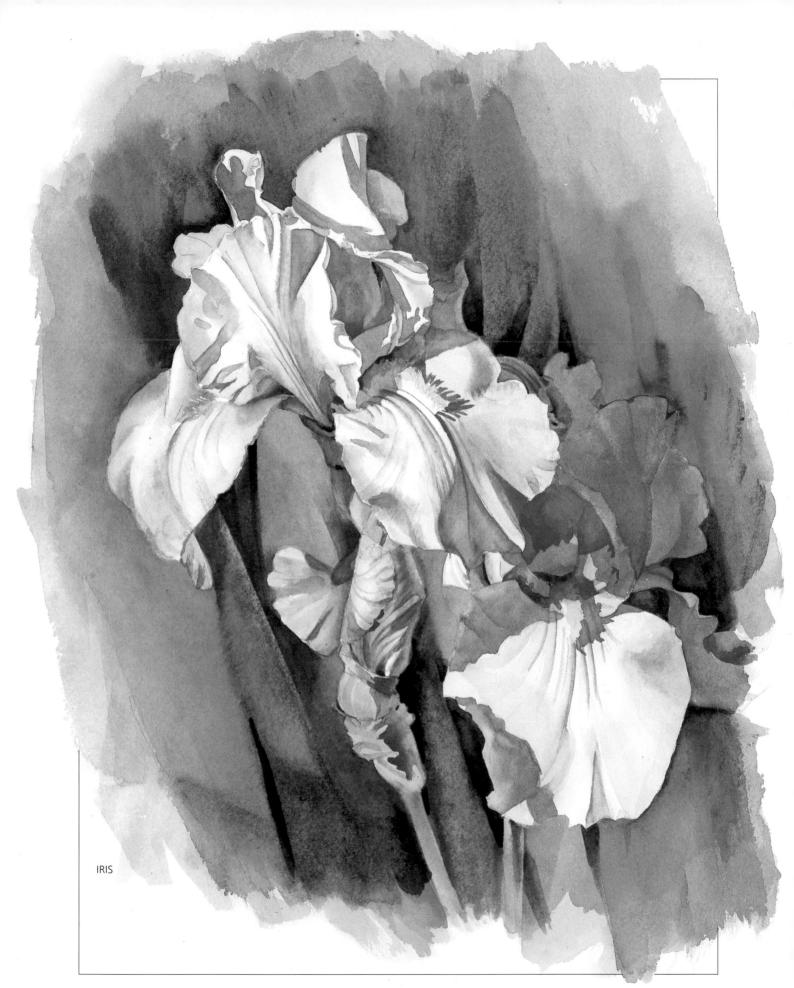

Anatomy of Flowers Simplified 33

STEMS AND LEAVES

While we usually think of all stems as slender cylinders, there can be subtle differences even between related forms. There are as many different stems and leaves as there are flowers.

Often, beautiful leaf arrangements are the focus of floral paintings. Close-up views of palm fronds lend themselves to semi-abstract designs. Fig leaves are exceptionally handsome. Some leaves look like long blades. Carnation leaves curl out from either side of the stem like upside-down cup hooks. Leaves can be paddle-shaped, circular disks. Observation is the key. Carelessly drawn or painted leaves can ruin an otherwise lovely floral painting.

Sometimes stems may not be visible in a crowded bouquet, but the flowers must always appear to be supported by logically placed stems. Obviously, you don't want to paint every stem, but you do want to suggest their presence. Stems or leaves that are carelessly placed can leave a viewer with an uncomfortable feeling. New leaves of some roses are reddish in hue. while others begin as varicolored or green. Most of the roses I know of have leaves with sawtoothed edges. Notice that the edges of the green leaves are red, as is the central vein and stem.

Salal leaves are thick and crisp. Florists sometimes use them as fillers. Their stems zigzag between each leaf, and in the spring, the stems, as well as the leaf's edges, have a rosy hue. Leaves are beautiful—they deserve as much attention as the flowers.

At first glance, these leaves may look like rose leaves. However, the saw-toothed edges are more pronounced, and the leaves, more slender. These are the leaves of an entirely different plant. See how a carelessly drawn leaf might diminish your painting?

At least some of the stems in the midst of the bouquet must appear to be extensions of those in front.

CHRYSANTHEMUMS

INCLUDE ALL THE INFORMATION YOU NEED

Take time to study the flowers you intend to paint. When you think you have finished your drawing, go back and look again at your subject. There may be more to see. In my workshops, when I point out a line or a shape that has been overlooked, the response is usually "Oh yes, I can see that!"

Learning to see is the first obligation of an artist. The rewards are many. Seeing as an artist will not only open the door to better painting, but it will also increase your wonder and enjoyment of the beauty of nature. Intellectually, we all are aware of the three-dimensional world in which we live, and we want to suggest that three-dimensional world in our florals. In this book, you will see that every flower, stem and leaf has its beginning as a basic form.

4

Painting Flowers From Life

Pansies, 15" x 22"

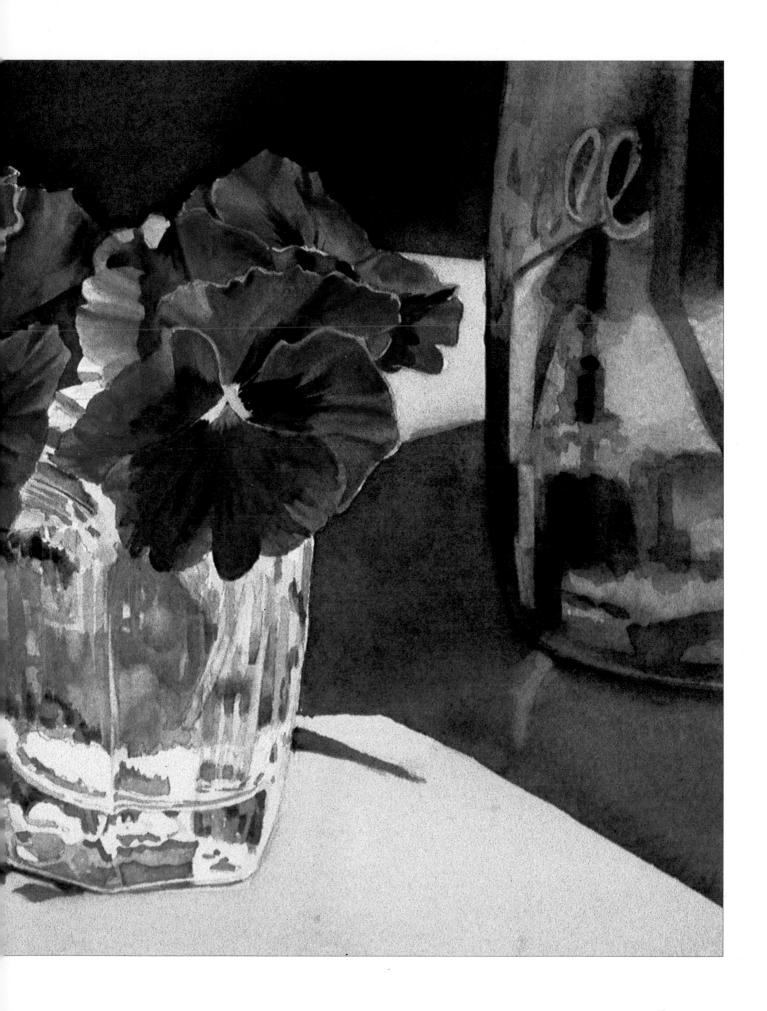

ainting from life can be a totally delightful experience. Painting outdoors is even more fun, especially if a basket lunch is close at hand! Whether indoors or out, finding the right subject is the first concern.

I think the best subjects are those that jump up before your eyes and say "paint me!" Usually it is the light, color, or darkand-light pattern that attracts us, rather than any particular subject.

Painting in a quiet garden on a sunny day can be pure enjoyment. However, if "getting a picture" is your goal, your concentration may be better in your studio (or on the kitchen table). Painting in the field is great fun, but the wind, changing light and accompanying insects provide numerous distractions.

WHERE TO LOOK FOR FLOWERS

It has been my experience that people enjoy sharing their gardens. If you ask for permission to paint their flowers, they may invite you to stay, and perhaps offer you a bouquet. Even your local nurseryman may permit you to paint in his display yard. Also, farmer's markets and flea markets are other places you'll be likely to find flowers to paint.

Almost every city has an area where artisans meet to share their crafts. Flowers, fresh or dried, are often part of the display. Olvera Street in Los Angeles is such a place. This block-long street is devoted to California's Mexican heritage. Colorful shops, eateries and flowers are everywhere.

Finding Cut Flowers

No doubt you already know the best place to find flowers in your neighborhood, but here are a

Funeral directors sometimes have leftover floral arrangements. A church may have altar pieces that won't last until the next service. Perhaps you know someone in a restaurant who could rescue any abandoned table decorations. A persistent artist is a force to be reckoned with!

Other Possibilities

I prefer to paint old-fashioned, familiar flowers. Roses, lilacs, pansies, carnations and countless others have been favorites for as long as we can remember.

Don't overlook the possibilities for design offered by many succulents. Also, jimsonweed, cat tails and skunk cabbage are all beautiful. You can create unique and colorful arrangements using such subjects as cabbage, artichokes, corn and corn husks, wheat, thistle, branches, pine cones, leaves and mushrooms. The list is almost endless.

There are some remarkably beautiful silk flowers on the market these days. Arrangements made of silk flowers have the added advantage of not wilting or fading under strong light.

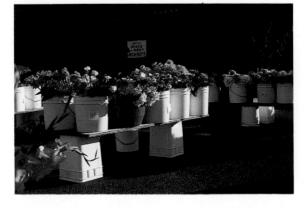

Flowers at a farmer's market in Albany, Oregon, are just waiting for a painter to discover them.

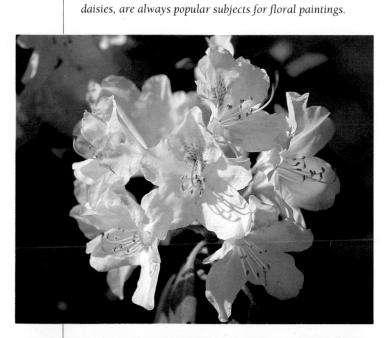

Familiar flowers, such as these rhododendrons, roses and

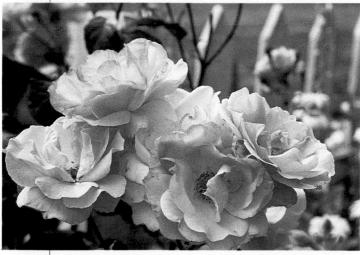

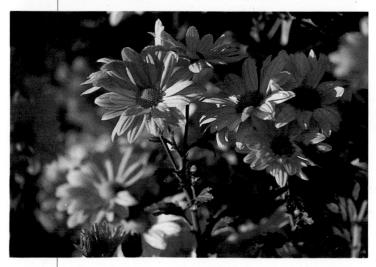

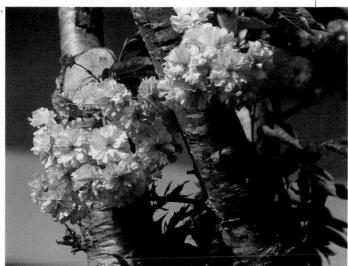

Cherry blossoms, autumn leaves, wildflowers and weeds are other possible subjects for a floral painting.

PROPS

If you are looking for props, it's possible to find interesting vases, glass canning jars, bottles or other objects you might use in floral setups at garage sales or in used furniture stores.

Any props you use should enhance your subject and never overwhelm it! Be sure that each object you include echoes a theme, and always avoid the temptation to include unrelated objects, no matter how beautiful they may be.

Strive for an Imaginative Presentation

Take advantage of people's tendency to associate flowers with special occasions. Flowers along with open boxes and a profusion of ribbons suggest a party. A corsage and a dance card might recall a wonderful evening. Wildflowers in a canning jar could be reminiscent of a friendly farm kitchen. The way you present your flowers is important. Try to feel empathy for your setting.

ARRANGING THE FLOWERS

Don't begin painting until you are satisfied with the overall shape and distribution of color within the arrangement, as well as the placement of the props.

Think about textures. Rough pottery containers, porcelain vases and baskets, along with a variety of other containers, offer opportunities for textural contrast.

Arranging flowers is something like planting a garden. You don't plant flowers just anywhere. For instance, keep the daisies together and perhaps add larkspur in another clump with a sprinkling of still another variety to connect them.

Try to place the flowers in various positions so that there are blooms visible from several angles. Some flowers have a way of staring straight at you, so try to tilt them in such a way as to divert their view.

Study your arrangement, and if things look cluttered, try substituting stems or blossoms for pots. In short, make sure the arrangement feels comfortable.

Flowers in a cup on my drawing board became a subject for a painting.

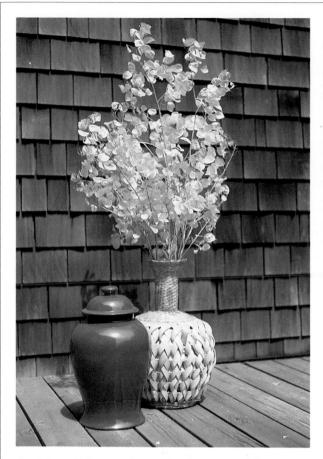

Straight-on lighting tends to make objects appear flat.

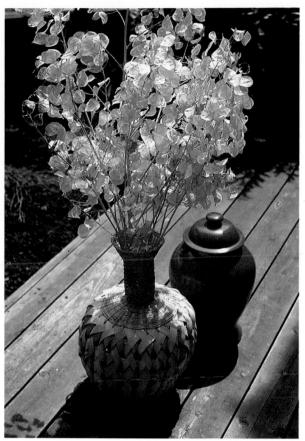

Imaginative lighting combined with an unusual viewpoint can add drama to any arrangement.

VIEWPOINT

Before you settle for a straight-on view, look at your floral arrangement from different eye levels. Try placing your arrangement slightly above (or below) your line of sight. Point of view can make a difference.

Close-up views of flowers or plants are a never-ending source of beautiful design. In the hands of an artist like Georgia O'Keeffe, one flower can inspire a masterpiece.

LIGHTING

Lighting is a major consideration in any setup. Remember, light must come from *one* direction and only *one* direction. I said that twice for emphasis! Whatever light illuminates your setup should also illuminate your painting area. If you let light come from more than one source, the light and shadow areas will become confusing.

I think it is best to arrange the light so it comes from one side of the setup. In this way each object in your arrangement has a dark and a light side. Straight-on lighting tends to make objects appear flat.

Look at these photos of dried leaves. I'm sure you will agree that the "straight-on" lighting and viewpoint is far less dramatic than the backlighted arrangement, with a "seen from above" viewpoint.

Always set up your arrangement under the same light you intend to use. In the final analysis, it is the pattern of light-anddark shapes you are arranging!

Mt. Fuji Cherry Blossoms, 22"x30"

Backlighting, as seen here, rather than standard toplighting, is one way to add interest and drama to your florals. Many flowers and leaves can appear translucent under the right lighting conditions. Backlighting works well with flowers that have especially translucent petals.

BUILDING A STAGE

The photos on this page show how to use an ordinary cardboard carton to construct a simple stage for your floral arrangement or still-life setup.

Cut the carton so as to leave the bottom and two adjacent sides. The sides become the background, and the bottom is the stage for your floral arrangement. If your box is a bit small, it is an easy matter to extend the sides or the bottom with matboard or craft paper. Next, select the props

Use a sharp knife to cut down along opposite corners of a large cardboard carton.

to include and decorate the stage to your liking. You are the stage manager!

Place the box so the light strikes one side of the background and the other is in shadow. With this setup, you can arrange the objects so their shadow side is seen against the sunny plane of the background and the sunny side of the objects stands out against the adjoining dark background.

This basic principle of light against dark and dark against

light makes each form easily recognizable. You can achieve other lighting effects by simply putting a cover across your stage setup.

Once everything is in place, photograph your arrangement. Time goes so quickly when you paint that the flowers may begin to fade before you know it. With your photograph for reference, you have the security of knowing your arrangement will last as long as you need it.

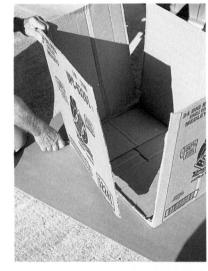

Cut along the bottom edge to remove two adjacent sides of the box. The remaining two sides and bottom of the cardboard carton become a stage for your floral arrangement.

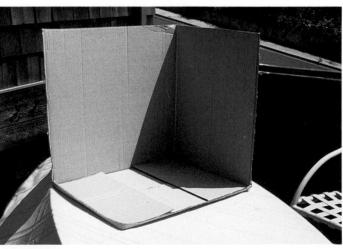

Place the stage so one surface faces the light and the other is in shadow. It is now ready to be decorated with your floral arrangement.

I added blue matboard for more color and draped a piece of fabric across the back. Next came a jug of dried leaves. The blue leaves repeated the color of the floor, and their shadow made an interesting pattern across the jug's surface. Finally, I added a vase of roses in the foreground.

Here is my painting from this stage setup. I used this same method (with different props) to paint the daisies and the chrysanthemums you will find in Chapter 9.

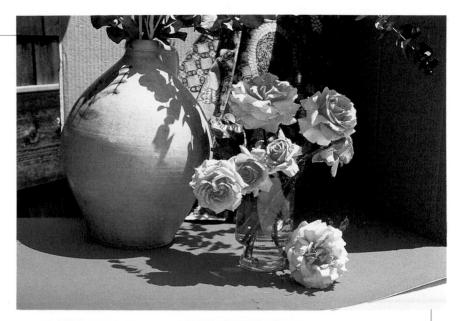

Painting Flowers From Photographs

Kwansan Cherry Blossoms, 22"x30"

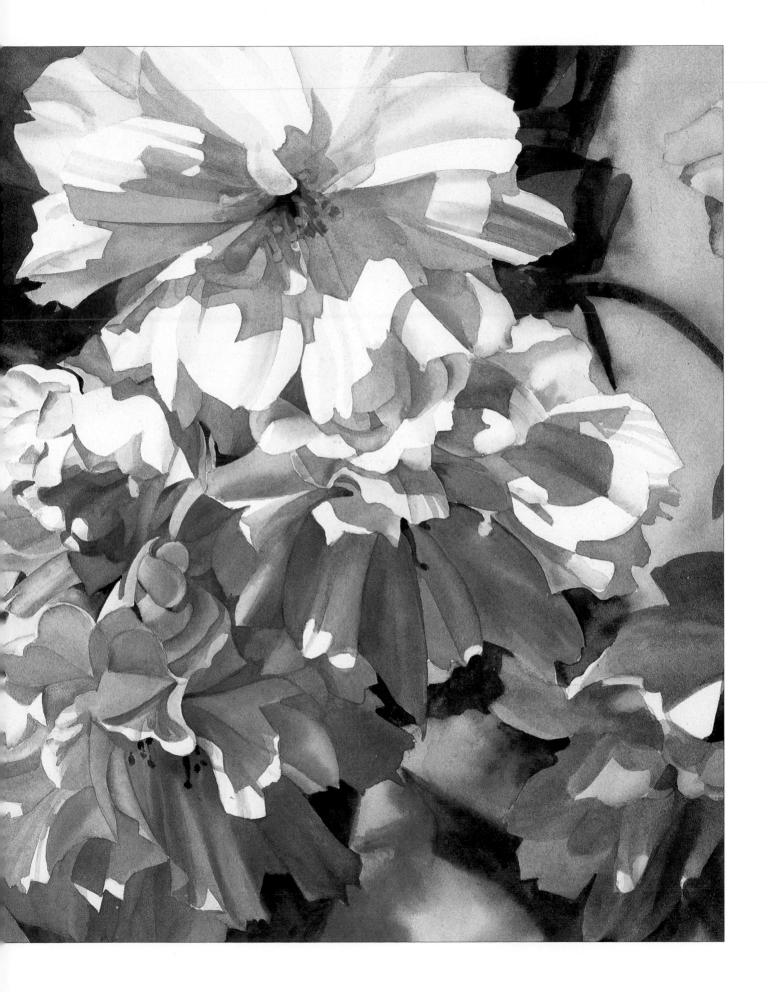

he advantage of painting from photographs is that once you have collected a number of photographs, you will never be without a subject

for a painting.

All summer long, I keep my sketch pad and camera at the ready. The flowers recorded during the summer months provide painting material for dark, winter days.

In addition to a large collection of flower photos, I have collected photos of beautiful vases and table settings. Home or decorator magazines can provide you with photographs of beautiful props to display with your flowers.

ACQUIRING A PHOTO COLLECTION

Today most artists have an extensive *scrap file*. A scrap file is a collection of photographs, newspaper clippings, magazine ads, sketches, or whatever a painter might use as reference material.

If you haven't already orga-

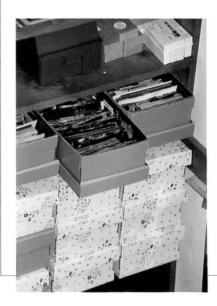

nized a scrap file, doing so may save you hours of searching for a particular item. I use cardboard shoe boxes to file my photos. The boxes aren't very elegant, but they do the job! The photos and clippings in my file document everything from a wagon wheel to a table setting.

Photographs offer another advantage. If you study a photograph carefully, you may begin to notice nuances of color and form not apparent through casual observation. Perhaps you can spot reflected light you hadn't seen before, or a place where light from

My photographs are stored in open shoe boxes. The closed shoe boxes on the shelf below contain slides. Each box is labeled on the outside. behind has caused a petal to become translucent. When you work from photos, you can work at your leisure and take time to experiment.

Using the Photos

Photographs help you gather subject material. But the way you organize and present this material should be uniquely your own. When you paint from life, you design your work and paint the things that make for good design. The same must hold true when you work from photos. Don't ever feel compelled to include everything in the photo. Pick and choose the elements that will help you create a pleasing composition, and rearrange them in the most pleasing way.

PHOTOGRAPHING FLOWERS

My experience with photography is limited. I am no photo expert, but I am able to get good photos with my 35mm cameras. One is a Minolta Maxxum 5000i with a 100-300mm zoom lens for use in photographing flowers at a distance. The other camera is a Pentax K1000 with a standard 50mm lens. I have a No. 2 Kalt close-up lens that attaches to the Pentax 50mm lens for close-in detail.

It's best to take flower photos on a sunny day. It has been my experience that even a light overcast can dull the brilliance and clarity of the color. The morning and afternoon hours provide the best shadow angles.

Remember to take photos of the stems, leaves, thorns, etc. Be

sure to record how the flower is attached to the stem and how the leaves grow. You may need this kind of information.

Slides or Print Film?

The decision of whether to use slides or print film is a personal one, since they work equally well. If you haven't made up your mind yet, here are a few things you might want to consider.

Cost: On average, print film and developing is about 20 percent more expensive than slides.

Filing and storing slides: Slides come in boxes, but they must be separated according to subject matter, put in new boxes, labeled and filed for easy access. In order to paint from a slide, you need a viewer or projector and rear projection screen. These items require separate storage.

Filing and storing prints: A good way to store print negatives is to mark the envelope in which they arrive with the date you receive them. By marking the back of the print in the same way, it's an easy matter to locate any negative. As for the prints themselves, they can be separated according to subject matter and filed in cardboard shoe boxes.

Over the years, I have collected many slides; they are a valuable but seldom-used resource. I work from prints because they store easily and they are easy to find and compare.

PITFALLS TO AVOID Flat Lighting

The photos of flowers you find, for example, in seed catalogs generally make poor subject matter. These photos are usually taken "straight on" with midday lighting, and there is little or no shadow. As you will soon see, we need shadow shapes to help create the illusion of a solid form and to create beautiful patterns in our floral paintings.

Panoramic Views

Fields of flowers are beautiful to see, but I do not recommend them as the basis for a floral painting. Such photos may be useful as material for backgrounds

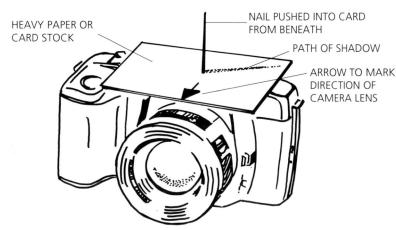

in landscape paintings, or as the basis for abstract patterns. It is much easier to create a floral painting with a few blooms and a closer view.

Scattered Look

Often, the flowers you find to photograph in a garden have a way of being separated from one another. Flowers seldom arrange themselves into paintable groups. Unless you plan to paint a single flower, you must be careful to avoid a scattered look. Your floral painting must never look as if it were designed by a shotgun blast or as the pattern for wallpaper.

THE "NEVER-FAIL NAIL"

It's very likely that at times you'll find it necessary to photograph several flowers (or one from several different angles) to get enough material for an arrangement you have in mind. If these photos are for use in the same painting, the light in each photo must come from the same direction. This can be surprisingly confusing. On these occasions I use my "never-fail nail." Just push a nail through a business-size card so that it pokes up vertically through the center. Draw an arrow on the card and point the arrow in the direction you intend to take the picture. Next, check the direction of the shadow cast by the nail. Be sure the shadow is in the same place on the card every time you take a picture. In this way you can be sure, no matter how many photos you take, the light will always be from the same direction.

COMBINE PHOTOGRAPHS

I know an artist who sometimes uses his projector to superimpose two slides one on top of another. The resulting image is often the inspiration for a painting.

Combining the images in different photographs is an excellent way to use your photo collection to find exciting floral subjects.

The painting on the next page

is a combination of elements in photos 1 and 2 (below). Because the direction of light is the same in both, I was free to use any part of either photo to compose the painting.

After you've chosen parts of several photographs that you'd like to use, the next step is to combine them to make an interesting composition. A shortcut to exploring several floral arrangement possibilities is to place a piece of frosted acetate or tracing paper over the photo(s) and trace the flowers you want to use.

When you have drawn several flowers on separate pieces of acetate, you are ready to rearrange them into a new composition by simply superimposing them upon one another and moving them around until you like what you see.

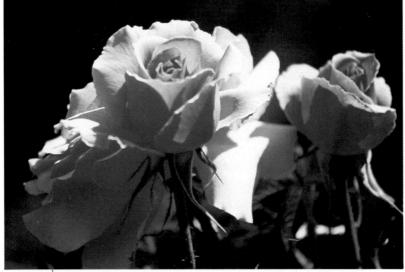

The elements of Photo No. 1 were traced onto one piece of frosted acetate.

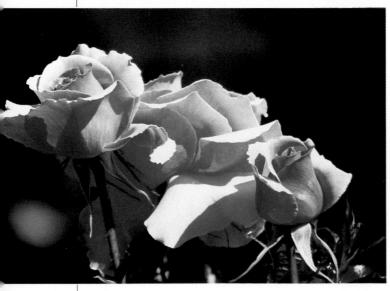

Photo No. 2

Photo No. 1

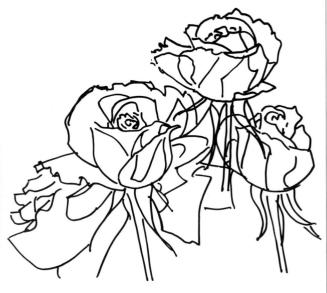

One rose from Photo No. 2 was traced onto another piece of frosted acetate, and was added to the tracing from Photo No. 1.

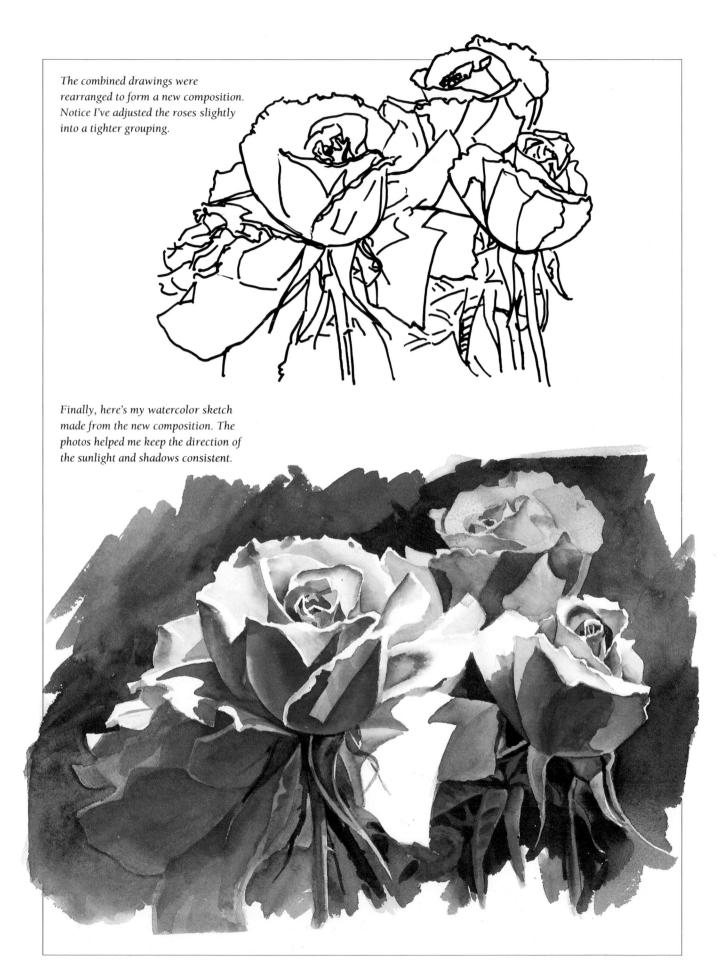

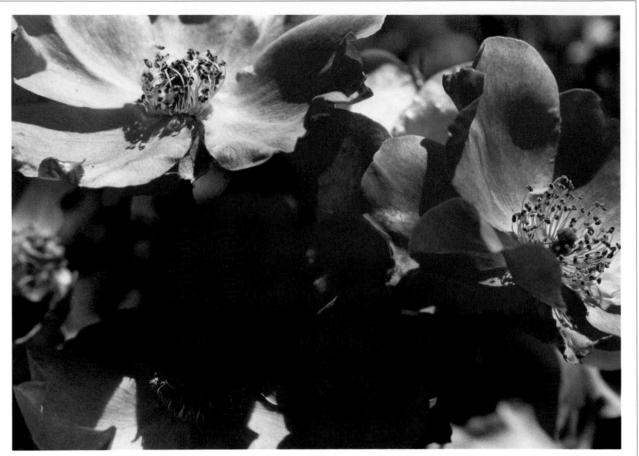

It is possible to find material for several paintings within one photograph.

SEVERAL PAINTINGS FROM ONE PHOTO

Often, you can find two or three beautiful floral designs within just one photograph. Make a couple of small "mat" corners from a piece of stiff paper and do some exploring in your photographs. In this photo, I found three designs almost immediately. This is a lot of fun, and you may be inspired to paint your first abstract!

Use small mat corners to discover painting subjects within even the most unpromising photograph.

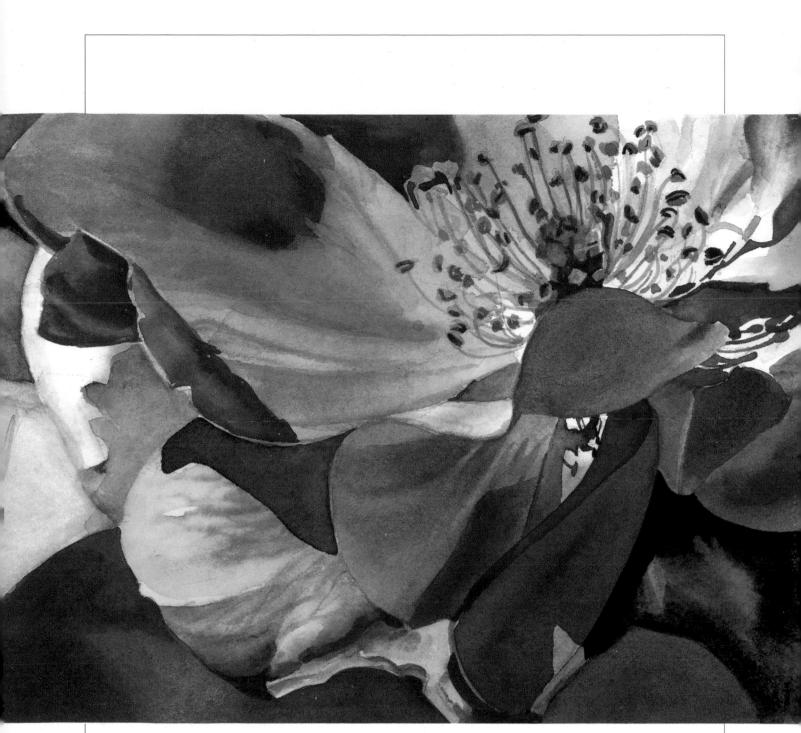

This is the "abstract" painting I did from a cropped portion of the photograph.

Composing a Dynamic Floral Painting

6

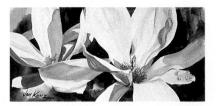

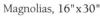

n simple terms, composition means selecting the elements you want in your painting and arranging them effectively. A well-planned composition is essential to a beautiful painting. No amount of fancy brushwork can compensate for poor composition.

Many good books have been written on the subject of composition. Since the purpose of this book is to teach floral painting, I will leave the in-depth discussion of the elements and principles of composition to others. We will concentrate here on how these elements apply to painting flowers.

COMPOSITION IN A NUTSHELL

Composition is one of those subjects that, once understood, seems simple, but trying to explain it is like participating in the Abbott and Costello comedy routine "Who's on first"!

The tools we use in art are line, value, color, texture, direction, size and shape. These tools are called the *elements of composition*. To achieve a unity of design, we must use these tools to tell only one story. In other words, some element must dominate the composition.

For example, suppose we were to paint an overall pattern of daisies. The repeated shape of the daisy would dominate the composition, and we would achieve design unity. We would have created a harmonious design because all of the shapes would be similar. However, our painting might be dull and uninteresting.

Like Tabasco sauce in cooking, the zing is added when an element of contrast is introduced. For example, we might add excitement to our painting of daisies by adding contrasting straight lines let's say a picket fence. Design unity would be maintained so long as the picket fence were kept *subordinate* to the daisies.

DESIGNING YOUR PICTURE AREA

The area between the boundaries of your watercolor paper is the picture area. You have already dealt with picture area if you have ever taken a photograph. When you look through the viewfinder of your camera you have to decide what to place within that little rectangle. Perhaps you want to include all of your subject. Perhaps you want to step in for a close-up view. In the,same way, you have to decide how large to make the important elements of your painting, and where to place them in order to make the most effective use of the picture area.

There are a few simple things to remember when you compose your picture. The objects must fit well into the picture area, not be unduly crowded toward any edge. In most instances, objects should appear comfortably placed. For example, you would not draw a vase too near the edge of a table.

The sketches on the next page illustrate how a composition can be improved by applying simple common sense.

This first attempt at composing the still life (top) is very weak. The gift bag, glass of roses and ribbon are all located in the center of the composition. The glass and roses conceal the gift bag and leave it almost unidentifiable. The negative space on either side of these central objects is nearly the same size and totally uninteresting. A ribbon, which could be used to draw the eye into the

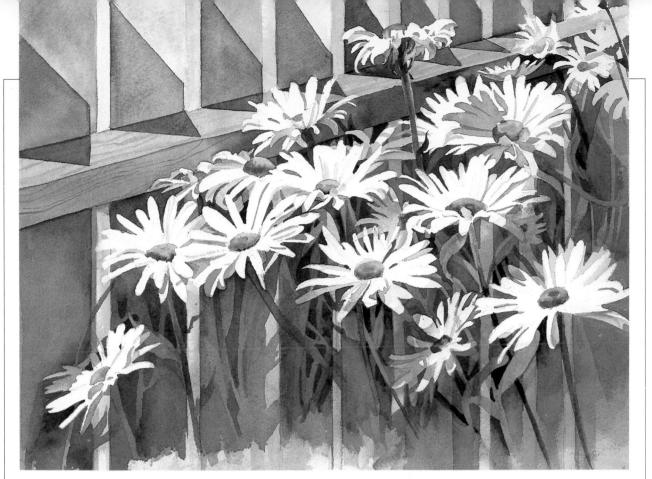

Backyard Daisies, 10"x121/2"

The repeated shape of the daisies is made more exciting by the contrasting straight lines of the fence.

composition, lies tangent with the bottom of the bag and becomes a meaningless addition.

(Middle) Moving the glass of roses and the gift bag farther apart makes these objects easy to identify. This move, plus the addition of a leaf, improves the shape of the background space. The ribbon still does not relate to the rest of the composition and tends to lead the eye in and out of the composition.

In the final sketch (bottom), I used the ribbon to lead the eye into the picture and to connect the various shapes. Better background (negative) shapes were created by moving the bag farther to the left.

Make it easy for your viewer to

understand and enjoy what you have to show him. Be sure every object is easy to identify.

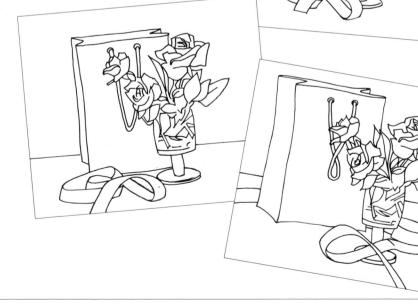

CREATING DOMINANCE

If you put only one object, no matter how small, in your composition, that object will be the center of interest, and the eye will be drawn to it. Things don't get tricky until you include other objects. Then you have to decide on their relative importance. Something must dominate so the viewer will know what you are trying to show him. You will use the principle of dominance along with other design principles to create your paintings.

DOMINANCE BY REPEATED SHAPES

In the sketch below, dominance is achieved by the repeated use of curved shapes. Not only do the pots and vase have curved sides, but this curved shape is repeated throughout the composition. The element of contrast is introduced with the radiating forms of the branches.

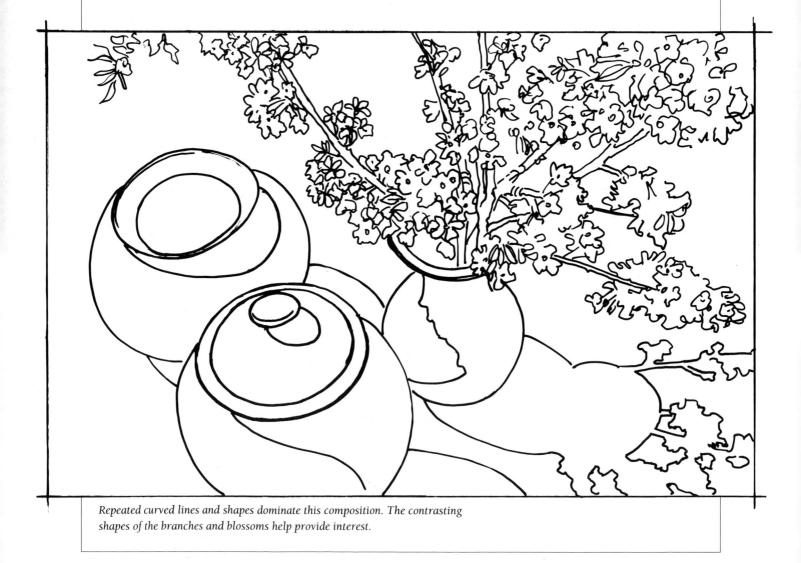

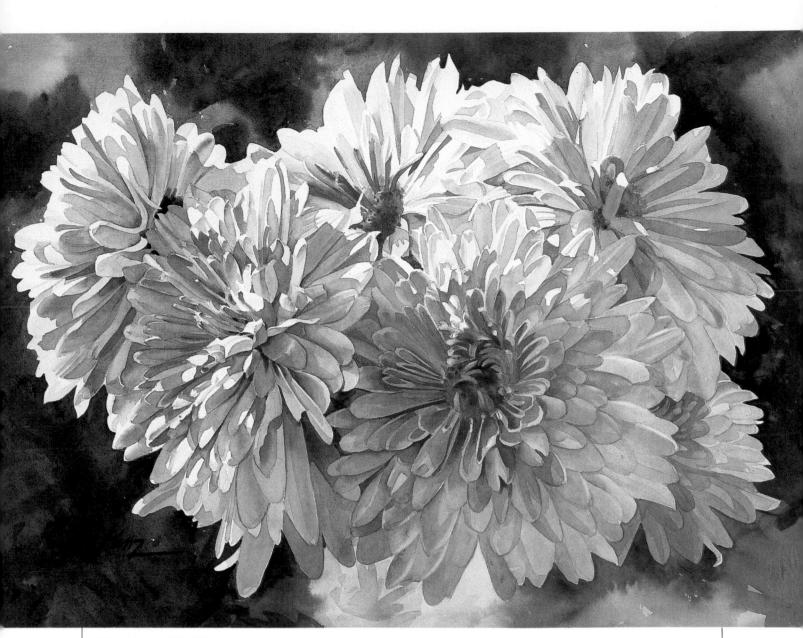

Maxi Mums, 22"x30"

Here the blossoms combine to create one dominant shape. The radiating petals provide interest.

SIZE AND DOMINANCE

You can vary the size of the objects in your composition to show what is important. One object can be made to overwhelm another, or dominate it only slightly, depending on their relative size. If you want your viewer's interest to be equally divided, you can make all objects the same size; but beware, such a composition can easily become monotonous. As you will see on page 61, design unity might suffer.

The branches in the sketch at the right dominate the composition. They overwhelm the secondary objects with their size and strong directional (radiating) lines.

When you use props or other objects in your composition, try to vary their size. Objects that are alike in size can appear uninteresting, even though they have different shapes.

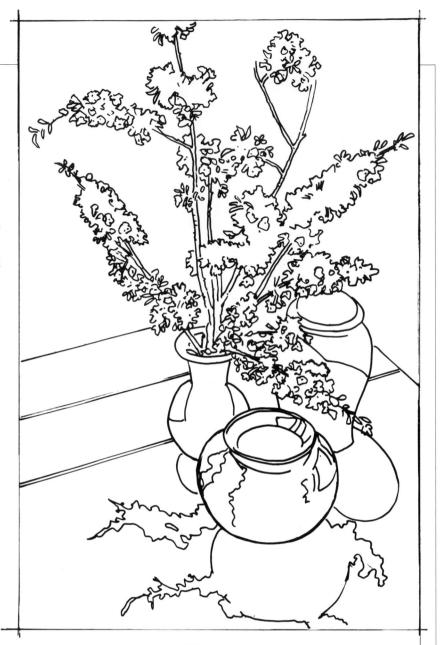

Blossoms radiating from the central vase are the dominant form because of their size and strong direction.

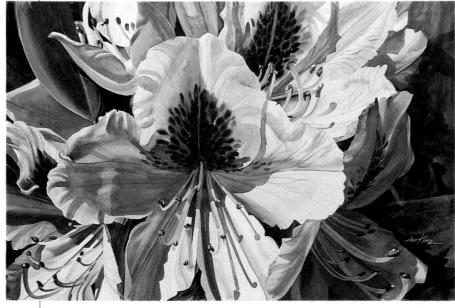

Rhodies, 26"x41"

This blossom dominates the picture plane because of its sheer size.

OVERLAPPING AND DOMINANCE

Another way to achieve dominance is by overlapping shapes. One object can be made to appear more important by partly concealing a secondary object behind it.

In this sketch at right, I have used both *size* and *overlapping* in an attempt to draw the eye to the largest pot in the foreground. But notice, something is wrong. The composition leaves you feeling slightly uneasy. The reason is that the contrasting elements demand too much attention.

Cover the top half of the sketch with your hand and the pot in the foreground becomes the dominant form I intended it to be. Design unity is restored.

Now look again at the sketch on the previous page. See what happens if you crop the top half of this sketch. Reduce the size of the branches and dominance is lost. Design chaos is the result.

We can make good use of the principle of overlapping shapes in planning our floral compositions. Many blossoms can be combined into a unified shape to dominate what might otherwise be a fragmented composition.

In this sketch (right), many small blossoms were united into one dominant form. The linear stems add contrast and interest.

The overlapping shapes of many small flowers combine to create an interesting design.

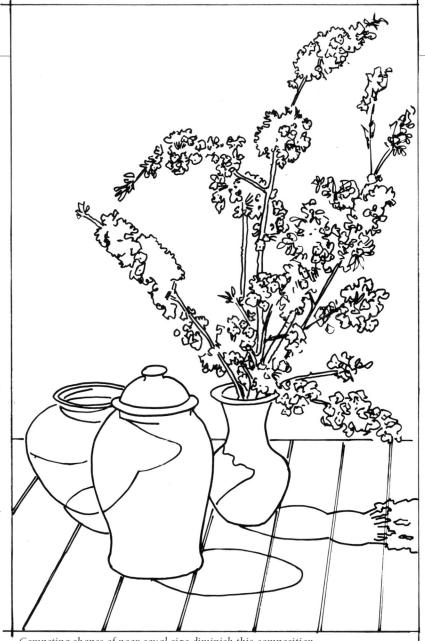

Competing shapes of near equal size diminish this composition.

Composing a Dynamic Floral Painting

CROPPING

Cropping is still another way to overlap shapes. Large parts of secondary objects may be cropped by the boundaries of the picture area so long as the part remaining clearly identifies the object.

DEPTH

As you remember, in Chapter 3 we talked about drawing through objects as if they were transparent in order to give them room in space. Another way to suggest depth in your paintings is to make background objects smaller, or as we just saw, to overlap shapes in front of one another.

Try to place the objects in your composition so they make a varied, informal pattern in depth. Don't stop with your first idea; sometimes you can increase interest by trying something new. It often pays to experiment. Don't be satisfied with a few trite arrangements.

LINE OR DIRECTION

We create directional kinds of lines with the objects in our paintings. By using line carefully, we can lead our viewer's eye through the composition.

Line can move the eye subtly and smoothly from one related object to another, or it can be a strong force resulting in an abrupt collision of lines. A line created by the edge of a table can forcefully direct the eye to the center of interest. Curved leaves or branches can be used to move the eye from one blossom to another.

Tony Couch, in his book Watercolor, You Can Do It, warned us to beware of the oblique. Strong diagonal lines can lead the eye out of the picture if they are not carefully planned. An art teacher once said, "If the lines in your painting point to the one hanging next to it, don't be surprised if no one looks at yours."

> Cropping is still another way to overlap forms.

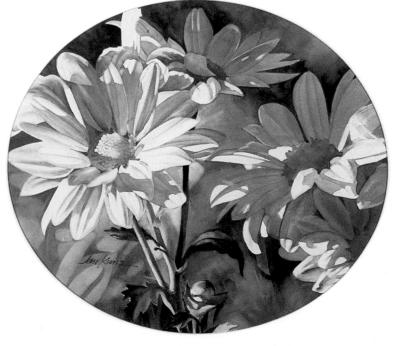

Sunny Daisies, 18¹/₂"x21"

The design principles of overlapping and cropping were both used in creating this painting of daisies.

By overlapping, the daisies' shapes were combined into one cohesive shape. Next, I used the borders of the painting to crop nonessential blooms, leaving only enough to suggest an abundance of flowers.

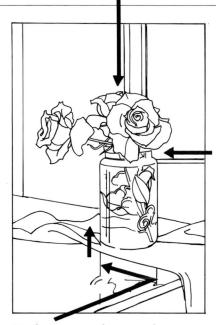

Use line to your advantage when you plan your composition.

Spring Bouquet, 22"x30"

The strong directional thrust of the branch directs the eye from blossom to blossom across the page. Notice that the same value relationships are maintained on the branch as on the intersecting blossoms.

Study the direction of the lines in your sketch. Ask yourself: Do the main lines keep the eye within the picture area, and are they spaced at interesting intervals? Asking questions like these will help you plan a better painting.

VALUE AND DOMINANCE

Value can be used in many ways to help your composition. For instance, value can draw the eye to the center of interest. Dark objects will stand out in a light area, or a light object can be

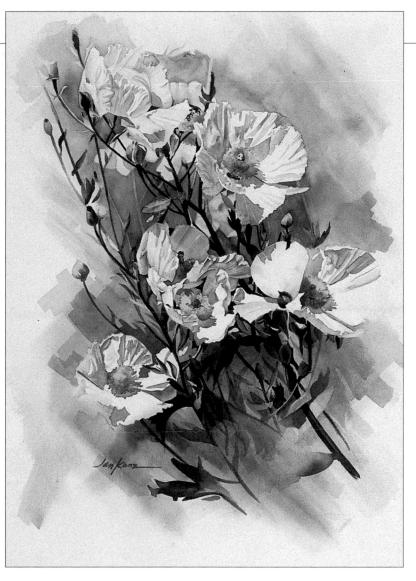

placed next to a dark one for emphasis. Value works along with line, area (or size) and shape to build the composition.

You have probably heard the word *key* associated with a particular painting. *Key* refers to the overall value of a painting. A painting in which all of the values are at the light end of the scale is considered *high key*. The overall value of a painting can be a major factor in creating a mood. For instance, to create a mood of mystery, you might want all of the values to be dark, or *low key*. As you can guess, high-key paintings might evoke a happier mood. A full range of values means all the values from white to black are used. I believe watercolor is at its brilliant best when used in a full range of values.

It is very important to remember that value relationships should be consistent throughout your painting. Deciding on a simple value plan before you begin to paint can increase your chances for success.

THE S.A.T. SKETCH

The purpose of an "S.A.T." (Stop and Think) sketch is to help you locate (and solve) potential problems before they confront you on your finished painting. For example, an S.A.T. sketch will force you to consider what you might do with the background before it jumps up to haunt you! My S.A.T. sketches are usually small (3"x5") pencil sketches.

Begin with the basic forms of your subject matter. You don't want detail yet. The purpose of the sketch is to design the overall pattern of the picture area. Think about the possibility of using overlapping shapes or discovering a new point of view. This is the place to experiment.

After you are happy with the overall design, try placing a clean piece of tracing paper over your layout and make several value sketches until you are satisfied. I use vertical pencil lines to darken these shapes because it helps me to see pattern, not things. By using tracing paper overlays for your value sketches, you eliminate the need to redraw your initial plan with every sketch.

THE S.A.T. SKETCH AND YOUR PHOTO

Let's suppose it's raining, and you have a great photograph of flowers you want to work from. You don't intend to do a preliminary sketch because you are going to do it just like the photo. Does that sound familiar? Chances are you may not have studied the photo carefully enough to spot problem areas, but no matter! First, place a piece of tracing paper or frosted acetate (frosted acetate works better because it is more transparent) over your photo. Use a pencil to outline every shape you see. Ask yourself: Are there too many shapes? Are too many shapes the same size? Can I simplify or reduce the number of shapes by combining shapes of near equal value?

After you are satisfied, place a new piece of acetate over your simplified layout to work out your value plan. Make the darkest shapes very dark, and so on, until you have a value sketch of your photo. Here again, I suggest that you use vertical lines so you won't see objects—just dark and light shapes.

At first glance, the photograph of three pink roses might appear to be a great subject for a painting without any changes. But by taking ten or fifteen minutes to study the photo with the help of an acetate overlay, I found a few problem areas.

The rose on the left is separated from the other two blooms, leaving a dead space between them. Also, the strong diagonal wedge in the upper-right corner becomes more obvious.

A simple solution might be to enlarge the central rose, or add overlapping petals to eliminate

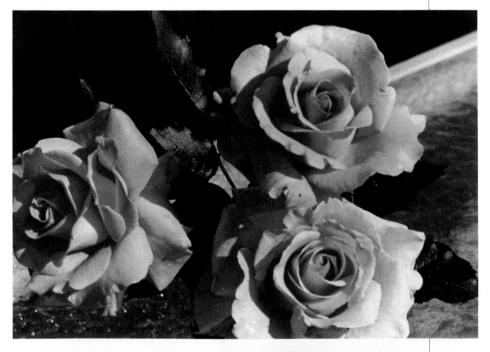

The simplified drawing identifies composition problems in this photo.

the center void. The wedge could become another curved shape. Still another solution would be to move the two bottom roses more toward the center, and to gradate the background values from darker on the left to lighter on the right.

Why not try this method next time you are tempted to paint directly from a photo? I think you will be surprised at how many problems you will be able to recognize and solve before you begin to lay out your painting. A few minutes spent in planning can be the fastest way to a successful painting!

I don't remember the exact words, but Maitland Graves said in his book, *The Art of Color and Design*, that we may perceive and respond to the design of a picture more than we respond to subject matter! Good art requires good design.

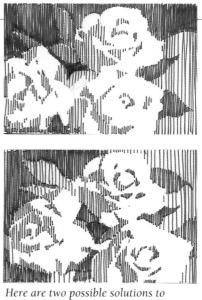

Here are two possible solutions to improve the design.

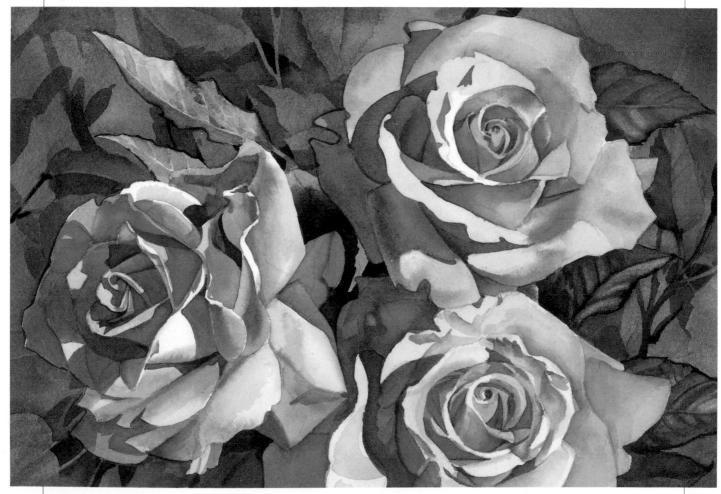

Pink Roses, 81/2" x 121/2"

I decided the third S.A.T. sketch solved the problems in the photo, so I did my final painting from that. Compare the painting to the photo to see how even subtle compositional changes can bring about remarkable results.

Painting the Illusion of Sunshine

7

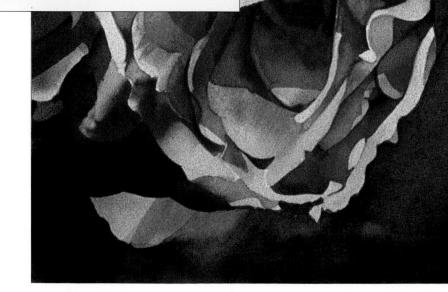

Dusty Roses, 18"x 30"

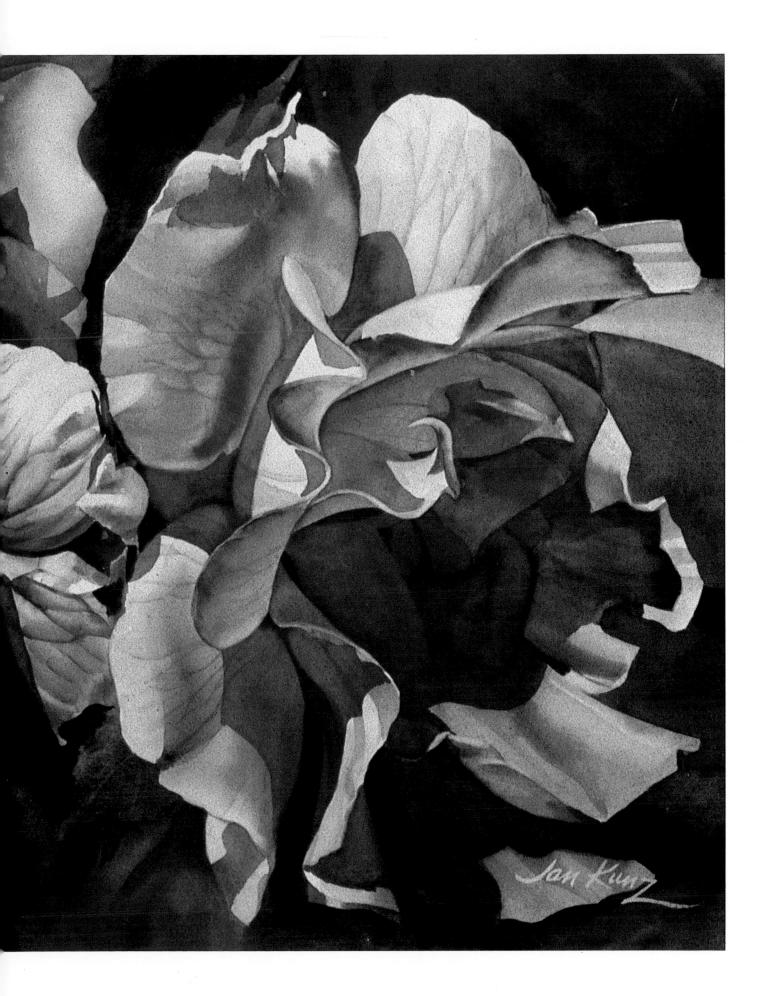

lowers and sunshine go together! We associate brilliance and color with floral paintings. So when you paint flowers, it is especially important to know how sunshine affects color. The photographs and paintings in this section will help you understand how to create the illusion of sunshine.

VALUE

Value refers to the lightness or darkness of a color. When you see a painter squinting at an object with eyes half-closed, he or she is probably trying to determine the object's value. When we squint, the hue becomes less dominant and we can see value.

If you have ever had a painting

photographed in black and white, you know the importance of good value relationships. A picture without good value relationships will appear flat and uninteresting. Commercial artists are especially aware that value is by far the most important aspect of color. It is also the most important element in helping you portray sunlight.

THE 40 PERCENT RULE

Landscape painters observed long ago that, on sunny days, the shadow side of an object is a full 40 percent darker than the sunlit side. All things being equal (objects identical in hue, value and texture), the cast shadow is somewhat darker still. Even the shadow sides of clouds are 40 percent darker than their sunlit areas. After years of painting and careful observation, I have come to believe that this value relationship is a basic fact of nature.

Fortunately, we can approximate these 40 percent value differences using an easy-to-make value scale. Scientists tell us the average human eye sees about ten or eleven distinct gradations in value. If we construct a chart with ten shades of gray evenly graded from white to black, using our off-

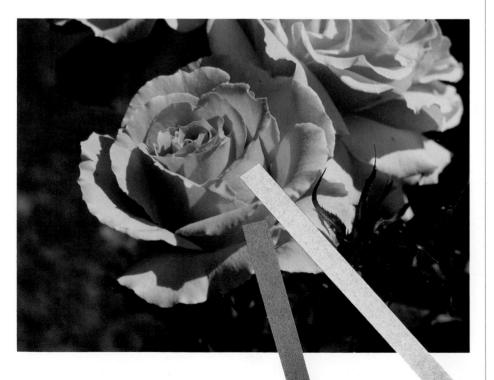

VALUE 5 -

VALUE 1

There is approximately a 40 percent value difference between the sunny and shadow sides of objects viewed in sunlight. Compare the value differences here to the value scale shown at right. white watercolor paper as value 1 and ending with black as value 10, we need only count up or down four values to arrive at a 40 percent difference. True, it won't be exact, but it will be near enough to ensure a successful representation of sunlight and shadow.

Look at the rose pictured at left. The area in sunshine is value 1, and the part of the rose in shadow is 40 percent darker, or value 5. The strips of watercolor I painted to match these values extend into the white area so you can see that this value difference is indeed accurate.

This same 40 percent value relationship holds true everywhere

under the sun. When the local color is darker, the shadow will be darker, too. See how much darker the shadows on the green leaves and stems appear in the photos of the fuchsia and poppies? This is because their local color is a darker value than the flowers they support.

At the right is a photo of the value scale I use. You can make your own by painting scraps of watercolor paper with washes of any dark color (I use Payne's gray). Gather ten evenly graded pieces ranging from white to black, and arrange and number them for easy comparison. You will have created a valuable tool.

A value scale is a helpful tool in measuring value relationships. To paint the illusion of sunlight, first determine the value of your subject in sunlight. Count four values down to get the value the same object will appear in shadow. Then simply match the value of your color to the gray value. You will have a reasonably accurate illusion of sunlight.

The value of the objects we see in sunshine will vary with their local color (the lightness or darkness of their actual pigment). The difference in value between the sunlit and shadow side is a constant. Above, the shadow side of the fuchsia is a mid-value because the local color, pink, is a very light value.

SUNLIGHT AND COLOR TEMPERATURE

Later, in the demonstration paintings, we will be concerned with the distribution of warm and cool colors within the painting. The purpose of this section is to explain how the sharp light of the sun affects the color temperature of objects.

We think of warm colors as those associated with fire. Yellow, orange and red are considered warm. Colors associated with water—blues and greens—are cool. Color temperature is important to understand, as you will soon see. The following experiments are meant to duplicate various lighting conditions you may come across in nature. I used a white box to simplify the effects and because color temperature changes are most noticeable on a white surface. The photographs were taken outdoors in bright sunlight. The box is placed so that one side faces the sun and the cast shadow falls across a colored board beneath it.

Sky Reflections

Can you see that the top of the box is cooler (more toward blue) than the vertical surface facing the light? This is because horizontal surfaces reflect the sky just as a pond reflects the sky on a sunny day. The value of the sunlit vertical side may be lighter or darker than the top of the box, but it will be warmer in hue (more toward orange). The side turned away from the light, like the top, is subject to the cool influence of the sky.

Reflected Light

In the photos on the next page, in addition to the lighted surfaces,

we can see the cast shadow as well as the shadow side of each box. We know the shadow side is 40 percent darker than the sunny side, but it is also subject to reflected light. The box on the top is receiving a blue glow from the paper upon which it is placed. The box on the bottom is bathed in a rosy glow from a nearby piece of rose-colored paper. Reflected light can fill shadows with brilliant color. Reflected color is not always as obvious as it is in these examples. Make it a practice to look for it. Observe the colors around your subject to give you a clue about possible reflected light on your subject.

Cast Shadows

The cast shadow is the same hue as the surface upon which it falls, and it is 40 percent-plus darker than the surrounding sunlit area.

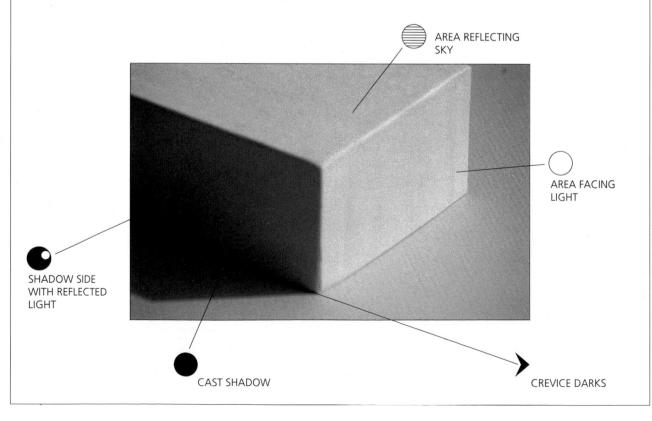

Painting Watercolor Florals That Glow

If the surface on which the cast shadow falls is dark, the shadow will be near black. Cast shadows do not contain reflected light.

Crevice Darks

Last, but very important, are the very small darks you see under the box at the edges. I call these *crevice darks*. These dark cracks are not affected by the sky; therefore, they are very warm. We will use these warm darks to great advantage when we paint the crevices and folds of petals.

CAST SHADOW (40 PERCENT-PLUS DARKER THAN SUNLIT AREA) CAST SHADOW

The shadow side of the white box in this photo looks blue because of reflected light. Cast shadows do not contain reflected light.

> Shadow Side

WARM (VERTICAL SURFACE FACING THE LIGHT)

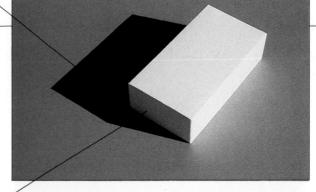

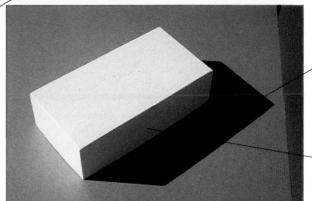

Reflected light can be any color. This box is receiving a warm glow from a nearby piece of colored paper. Notice the tiny wedges of dark that anchor the box to the table. These are crevice darks. CAST SHADOW

SHADOW

SIDE

COOL (HORIZONTAL SURFACE FACING THE SKY)

Although more complex in shape and form, a sunlit rose follows the same principles of light and shadow as a plain white box.

WARM (CREVICE)

LOCAL COLOR

Painting the Illusion of Sunshine

Up to this point, we have been talking about light and boxes, but how does this relate to flowers in the garden or the vase? Flowers are a collection of graceful curves and rounded shapes—much more complex than a white box. Shadow sides, shade, cast shadows and crevice darks are everywhere within one bloom. But the same principles you just observed with the boxes also apply to flowers.

As you probably suspect, curved surfaces facing the sun are warmest at the top of the curve and then cool as they turn from the light. Reflected color often affects only a portion of a petal, and cast shadows abound. Though these areas demand our observant attention, they are also what make flowers so beautiful.

Now let's put it all together. In the photograph of the white magnolia blossoms (below), we can see all the aspects of color temperature and value.

Why not try this experiment yourself? On a sunny day, place a box outside so that one vertical side faces the light. Observe the color temperature differences on each surface. Next, try placing brightly colored paper adjacent to the shadow side of the box. Notice that reflected light is just that—*light*! To observe color temperature changes on a curved surface, use a can or look at a tree trunk in full sunlight. These changes are most obvious in the morning or evening hours. Once you become aware of varying color temperatures, you can apply this knowledge to everything you paint, including your florals.

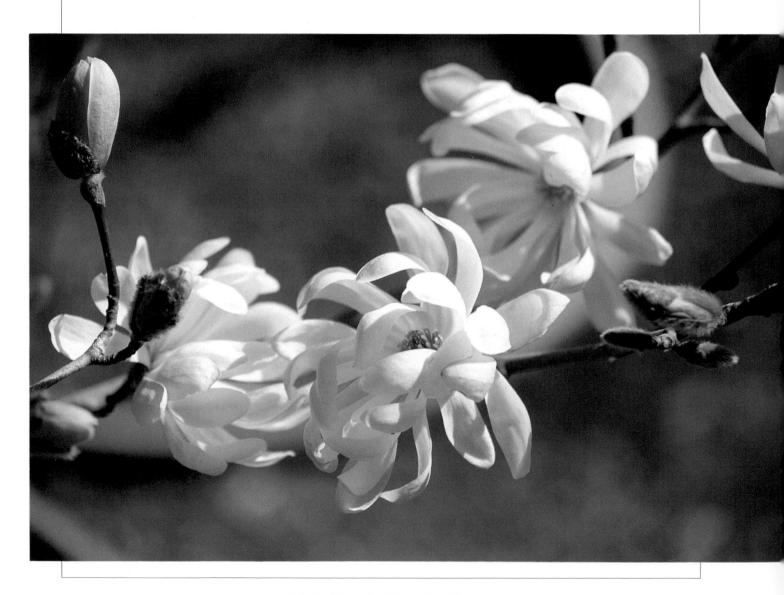

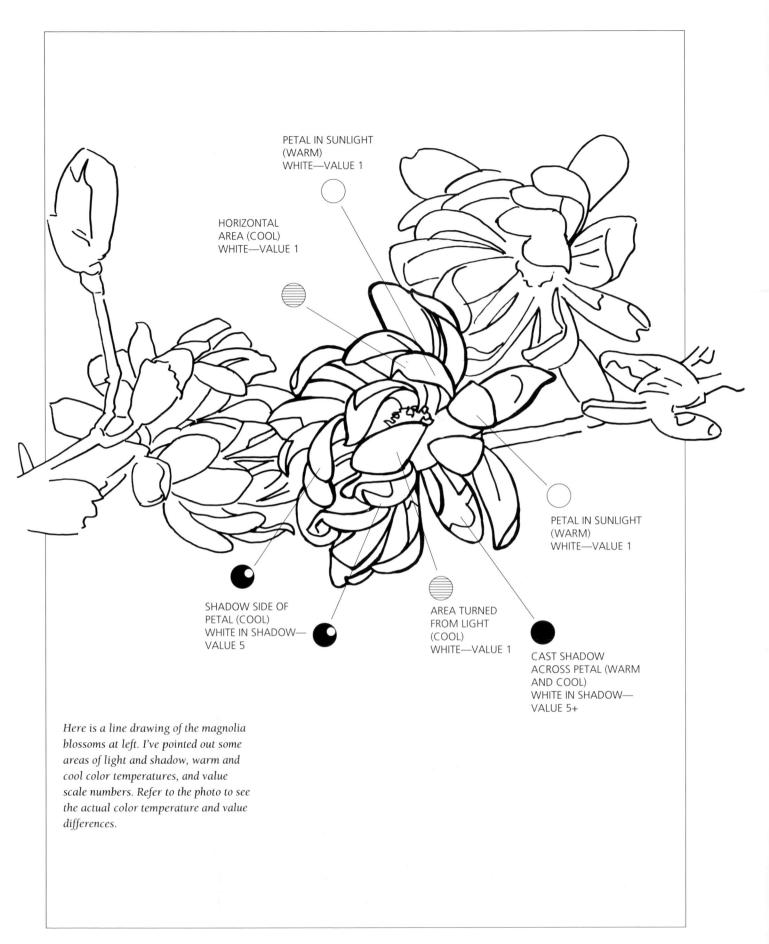

USING COLOR TEMPERATURE TO ENHANCE COLOR

Let's paint a poppy using what we have learned about how the color of objects is affected by sunlight. I have drawn the poppy for you so we can concentrate on painting.

AREAS FACING THE SUN

Step 2: Study the drawing and paint a very pale wash of new gamboge on the vertical surfaces that receive direct light. Notice I did not paint a solid yellow across these petals. Rather, the edges are a slightly deeper hue that quickly washes out to paper color.

AREAS REFLECTING THE SKY

Step 3: Paint horizontal areas that reflect the sky, or petals that turn from the light, with a pale wash of cobalt blue. Notice how, at first, petal A faces the light, then it turns, so the color temperature becomes cooler. The yellow center is painted last.

А

Step 1: First, sketch the poppy onto

your watercolor paper.

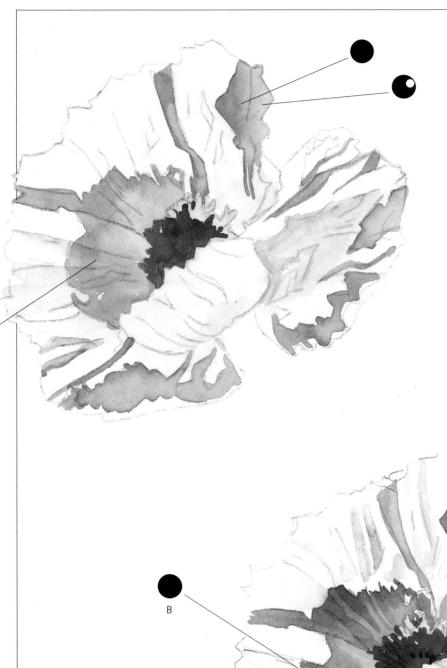

CAST SHADOWS AND SHADOW SIDES

Step 4: Mix a puddle of cobalt blue with a touch of Winsor blue and test it to be sure it is value 4 or 5 when dry. Once you are satisfied, paint the shadow shapes. Your brush should hold enough pigment to paint the entire shadow area. While the paint is still wet, "charge in" new gamboge and rose madder where you want to suggest reflected light. I know the color won't go exactly where you planned, but resist the temptation to make corrections. Everything will take its place in the next step. To go back is to invite trouble.

Decide on the value of the yellow center and paint the shadow four values darker.

FINAL MODELING, DARKS AND DETAIL

Step 5: Use a middle-value cobalt blue to model the shapes that give the wrinkled appearance to the poppy. You can use the same blue to model shapes within the shadow areas. Next, darken the cast shadows where required (areas A and B).

The final step is to suggest the stigma with the addition of crevice darks in the center of the flower.

Reference of Essential Floral Painting Techniques

8

Sunny Side Up, 20"x26"

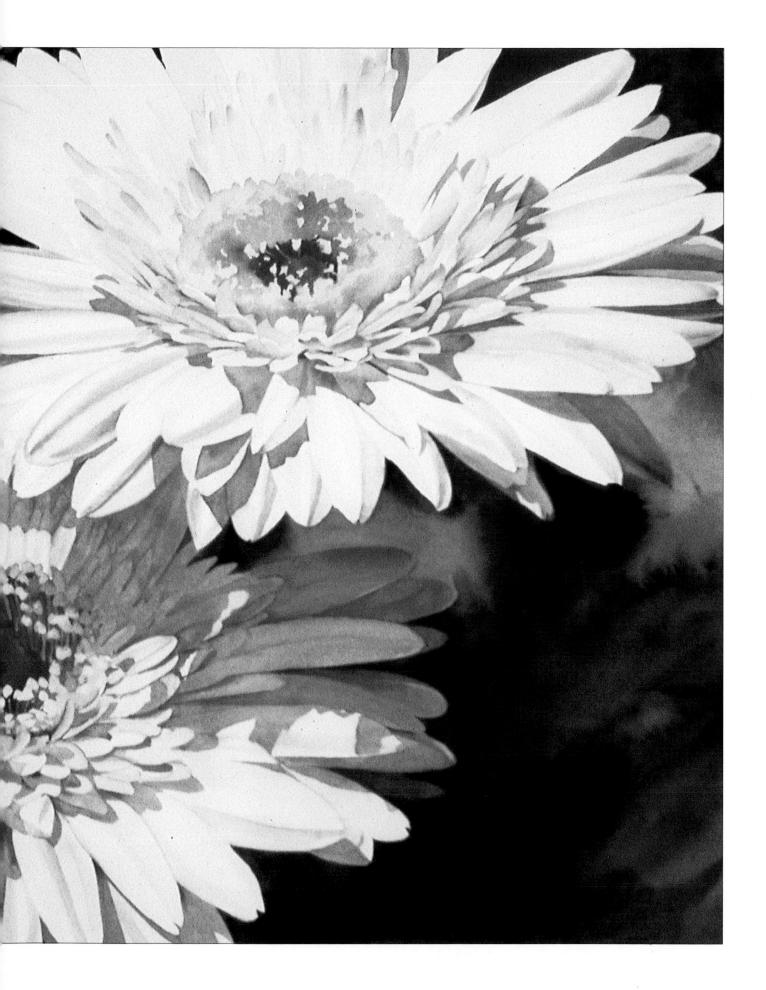

he purpose of this chapter is to provide you with an easily accessible reference for handling many of the recurring elements you will encounter in

floral painting with watercolor.

Before we get into some of the special techniques for flower painting, I want to cover a few areas that beginning and even experienced watercolor painters sometimes have trouble with: using enough water, and dealing with run-backs, or balloons.

HOW MUCH WATER?

Learning how much water it takes to create the effect you want is

basic to successful watercolor painting. Getting it right takes practice. Most of the beginning painters I know don't use enough water. So, if you are having a problem, perhaps you need more water in your brush.

In my workbook series, *Painting Children's Portraits* and *Painting the Still Life* (North Light Books), I introduced a scale of wetness that will help us now. In the demonstrations that follow, I will refer to the following terms:

Dampen: Wet the paper so it has absorbed some water but is not saturated.

Moisten: Wet it so it has absorbed all the water it can hold.

Wet: The paper is beyond saturation and the surface glistens in the light.

Puddle: The water stands on . the surface and will run if you tip the paper.

We need one more definition here. Oftentimes I will say the brush should be *fully loaded*. To be fully loaded, the whole brush, not just the tip, is made to hold all the water it can without dripping.

The sketches below illustrate how to prepare a fully loaded brush. Remember, the size of the brush you use should always be

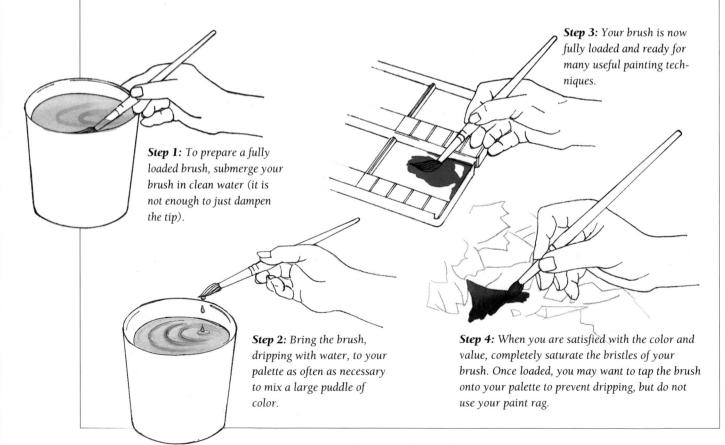

determined by the size of the area you intend to paint. Just because you need a fully loaded brush doesn't necessarily mean you need a large one. Generally, a fully loaded brush is used on dry paper.

When you paint with a fully loaded brush, you will make a puddle of color on the paper. The advantage is that you will be able to control the edges and move the color around freely. This puddle of color also gives you the opportunity to "charge" colors into the wet surface.

RUN-BACKS, OR BALLOONS

Many students ask me about *runhacks*, or *halloons*. Run-backs happen whenever wet pigment (or water) is added to a surface that has begun to dry. Or perhaps an area you've painted has developed a puddle near the edge, leaving part of the passage considerably wetter than the rest. Left to dry unattended, the moisture could seep back into the drying surface and create a run-back.

If you use a hair dryer to speed drying time, be careful to hold it back far enough to dry the surface uniformly.

It is sometimes possible to correct run-backs. Once the surface is thoroughly dry, use your regular brush to paint over the passage with clear water. This is often enough to "lift" the offending pigment and distribute it evenly. If the whole area you are painting is uniformly wet, the color will blend smoothly.

Run-backs happen when moisture is added to a surface that has begun to dry (top), or when a puddle is left to run back into a drying surface (bottom). Try to keep the painting surface uniformly wet.

Charging Color

Watercolor is unique in its ability to blend from one hue to the next in a cascade of flowing color. Learning to control and direct this marvelous medium is what keeps watercolorists fascinated (and confounded).

At some time, most of us have added pigment to a wet passage and watched the colors blend. This technique is used in several demonstration paintings in Chapter 9. *Charging color*, as described here, is a slightly different technique. In this exercise, we will begin with one color in our brush and add different colors as we cover more of the dry surface.

Almost everything you do in watercolor is dependent on mastering these wet-into-wet skills. You need to charge color to make a petal appear to bend, to add a variety of color to a background, or to introduce reflected light to a shadow side. In these sketches and in those to follow, you will see that charging color is basic to painting watercolor florals.

Our subject here is one of the magnolias taken from the photograph and drawing on pages 72 and 73. The basic shape of this blossom is a sphere. The final painting must maintain this spherical shape.

First, study these individual petals to help you understand how all of them are painted.

Then, with a fully loaded brush, paint a puddle of new gamboge along the edge of the petal on the left (A). Next, add a fully loaded brush of rose madder genuine next to the yellow puddle. Now you have a bigger puddle of blending colors (B). Use a fully loaded brush of cobalt blue along the top edge (C). Now, ease off. If the puddle is unmanageable, use a clean, thirsty brush to carefully pick up excess water along the side, but do not go back to correct the color. In this small space, the colors will stay more or less where you put them.

Use the same technique on the next two petals. The larger petal receives a long passage of rose madder genuine to suggest light penetrating through the overlapping petal (D).

Continue with this technique to develop the blossoms you see here. Notice how closely the overall shadow pattern matches the original sphere shape. Cast shadows and details are added to complete the sketch.

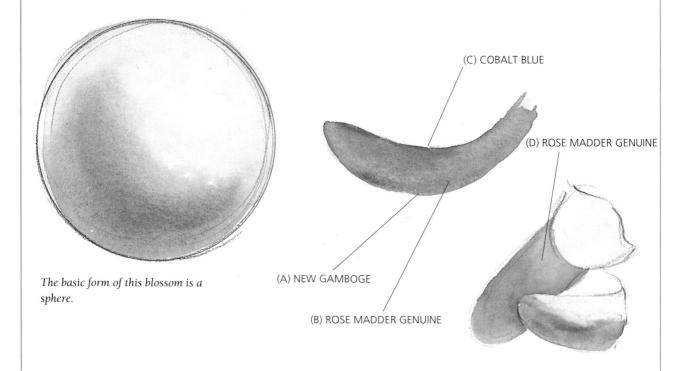

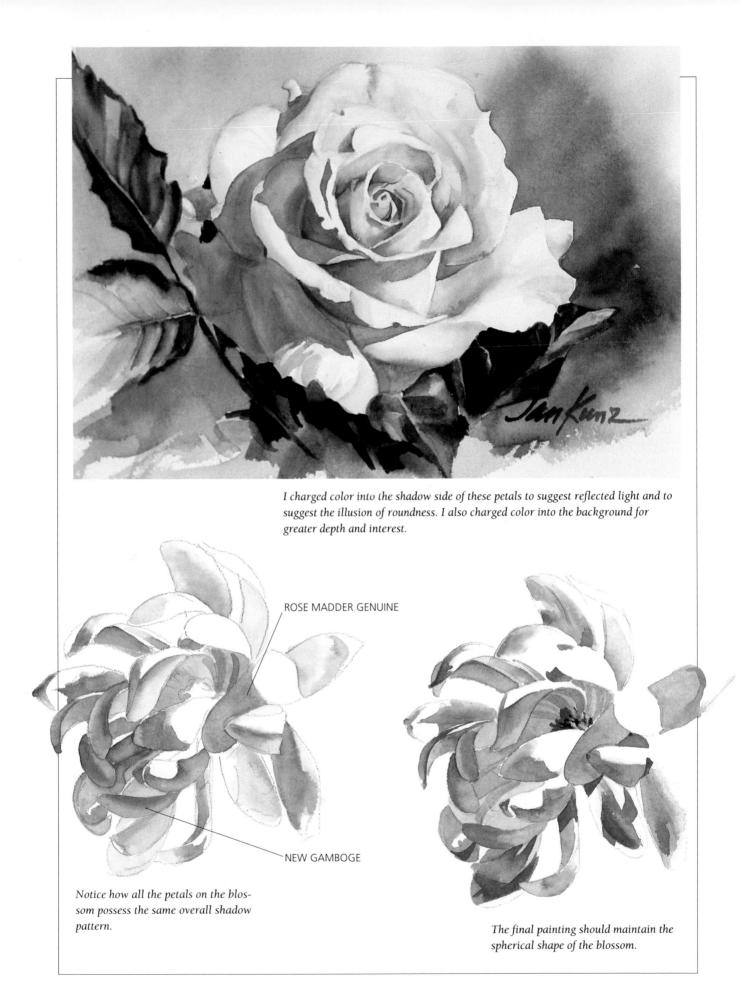

Backgrounds

There may be times when you want to suggest the presence of foliage in the background. To accomplish this, I begin with a charged wash. Once that's dry, I look for color and value changes in the wash to suggest emerging shapes. It takes a bit of imagination, but as you can see from the sketch below, foliage shapes can be discovered and developed easily from a charged wash. This technique is useful when painting other subjects as well. In my painting *Sunday Afternoon*, many of the flowers behind the central figures were developed by painting around discovered floral shapes in the background wash. The same technique was used to create a bower of leaves behind the girls' heads in *The Sisters*.

BLENDING COLORS HEAVIER PIGMENT

> To suggest background foliage, begin with a charged wash. Look for places where some of the pigment is heavier, or where colors blend.

Use light values of cobalt or Winsor blue to reinforce some of the emerging shapes.

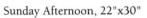

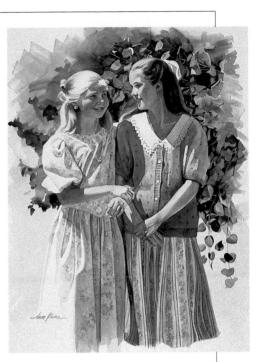

The Sisters, 30"x22"

"Discovered" floral and foliage shapes surround the central figures in both these paintings.

Add a darker color to make new shapes within and around the shapes you have outlined. Continue developing leaves and stems until you have achieved the desired effect.

Painting Lush Greens

When colors blend on the paper (rather than in the palette), the resulting mixture is brilliant and creates movement. Experiment by painting puddles of various yellows, blues and greens, permitting them to blend on the paper. You will discover a wide variety of intriguing greens. Don't forget to charge in a few warm colors. You may want to suggest places where the leaves have been burned by the sun or have begun to change color.

Keep in mind, unless you are making a poster, it is never a good idea to use just one color to describe the leaves and stems in your painting.

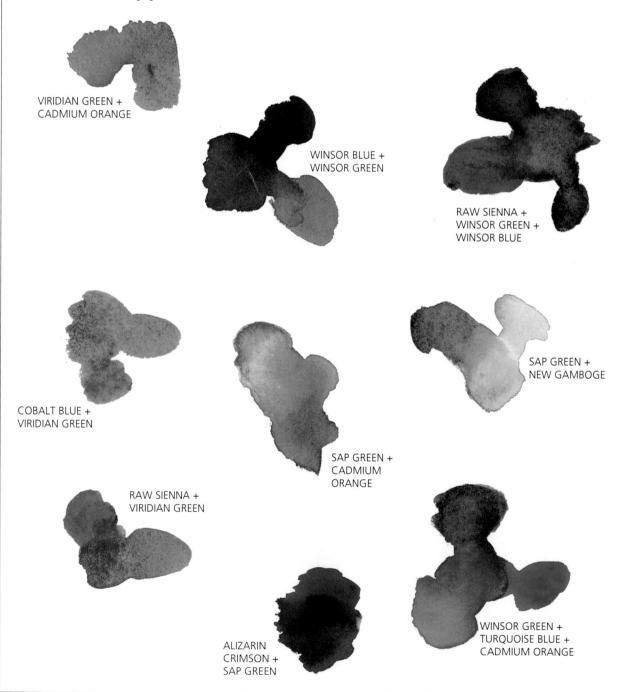

Painting Watercolor Florals That Glow

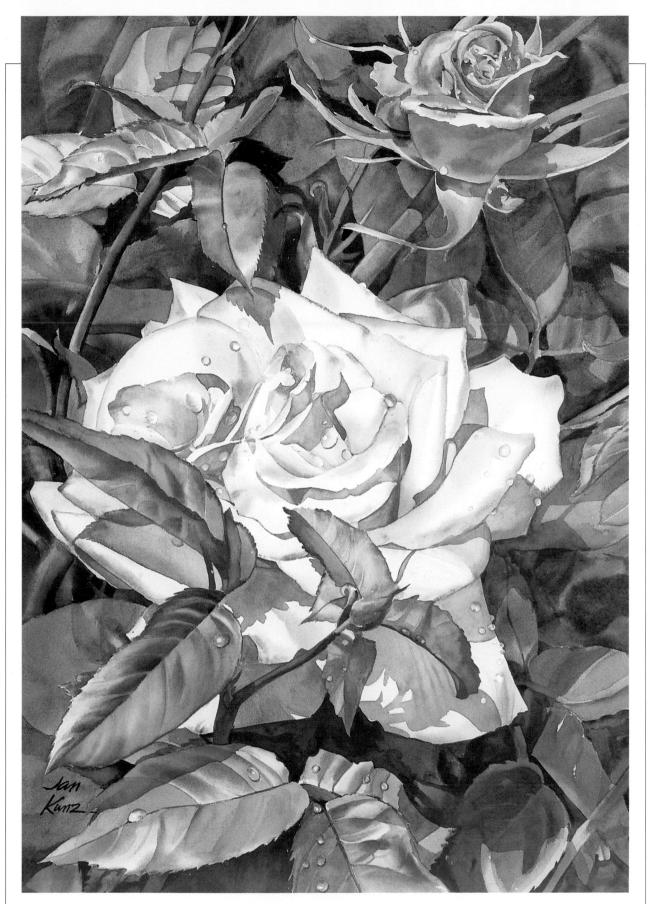

Peace Rose, 30"x19"

How boring this painting would be if I had used only one color of green, right from the tube, to paint the background stems and leaves. As it is, there are dozens of colors—both warm and cool—making up the overall green of the rose leaves.

Curled Edges Receiving Reflected Light

Many petals and leaves have curled edges, and depicting them presents a wonderful opportunity to add color and brilliance to your floral painting. We can achieve the illusion of curled edges by remembering that surfaces become cooler in color temperature as they turn from the light. Frequently, curled edges also receive reflected light from an adjacent petal.

In this illustration, the petals of the rose curve in many directions, but the painting process is very much the same for all of the petals. Let's take a closer look at the petals in the boxed area. At right are three stages of development. I have exaggerated the color and shadow shapes to help you see how they were painted.

Many flowers have rounded and curled edges. This rose has numerous petals that curl in many directions. Notice that the surfaces facing the sky have a considerably cooler color temperature.

Painting Watercolor Florals That Glow

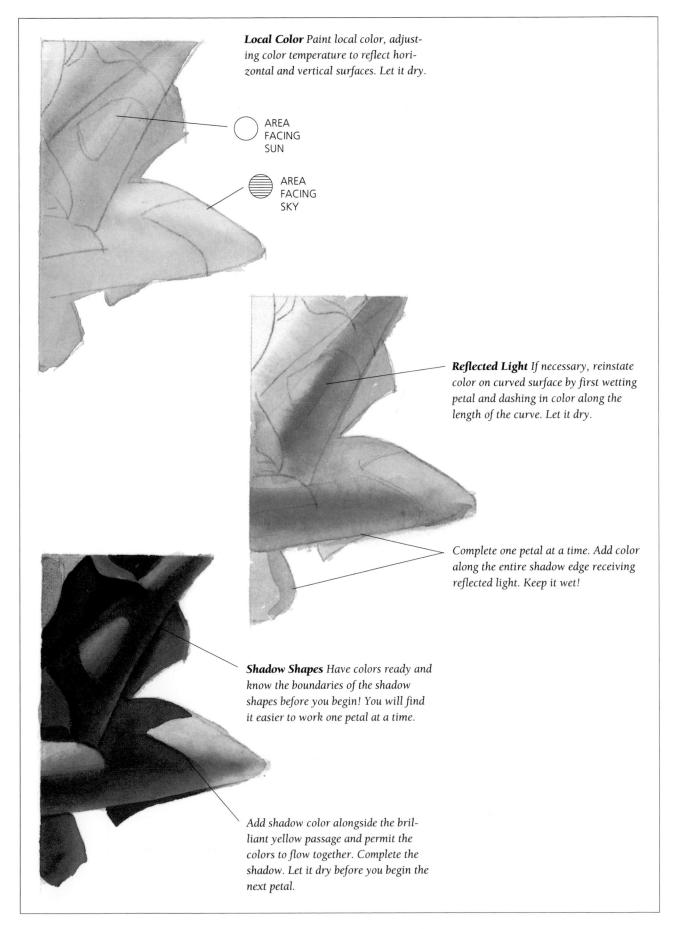

Reference of Essential Floral Painting Techniques

Painting Around Complex Edges

A large background can be painted a portion at a time and still look as if it were completed in a single spectacular wash. You can paint as far as you feel you have control of the medium, stop, let it dry, and then begin again. The trick is to keep the overlapping edges soft.

This technique is especially valuable when you paint around the complex shapes of blossoms. Plan ahead and have a place to stop before the paint begins to dry. Remember, painting an area that has begun to dry is what causes run-backs. **Step 2:** Before painting around the petals, prepare a place to stop by wetting with clear water an area at a comfortable distance.

Working on dry paper, paint around the petals with the background colors. Stop at the wet boundary you have prepared and permit the colors to flow into it.

Step 1: Paint the flowers and stems first and let dry. Next, paint small areas between the stems and permit to dry.

Step 3: Make everwidening circles of color until the background is complete. Be sure to make the pre-wet area wet enough and wide enough (at least $\frac{3}{4}$ ") to prevent a hard edge.

Step 4: Add any details after the surface is dry.

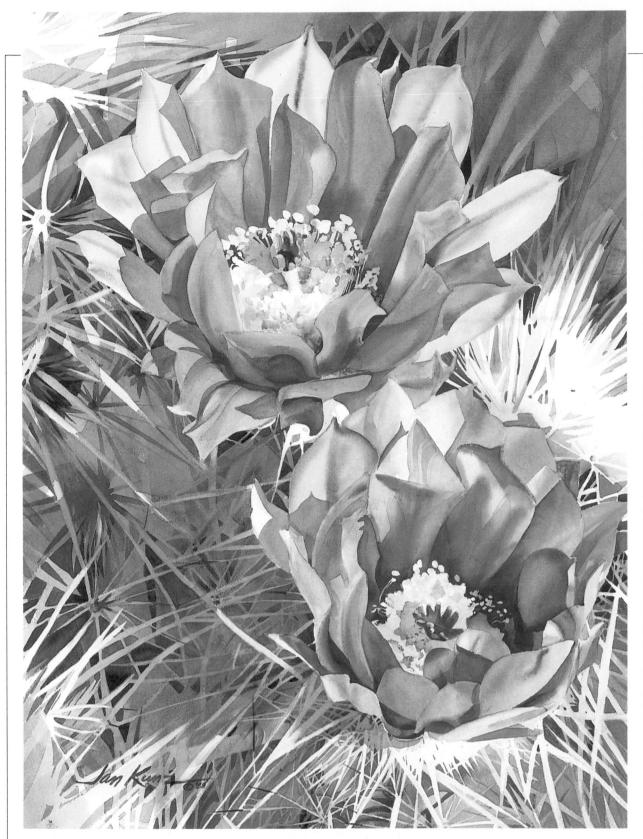

Cactus Flower, 30"x19"

The cactus spikes provided natural stopping places for the background color, thus giving me ample time to carefully paint around the cactus flower's petals. In some places, I painted to a straight edge, leaving a white spike. Places where background colors overlapped were concealed with the addition of a darker spike. Still other spikes were lifted with the use of an acetate frisket (see Chapter 1). I did not use liquid frisket in this painting.

Cast Shadows

We have already seen how dark cast shadows must be to represent a sunny day (Chapter 7). Not only should they be the correct value and logically placed, but they should suggest the shape of the object that cast them.

Cast shadows, like reflected light, offer an opportunity for color and interest. Since our eyes are accustomed to making the comparison between the edge of the shadow and the sunstruck surface, we think of shadows as cold and dark. We can add interest to shadow shapes if we take advantage of this phenomenon by painting the shadow's edges a cooler hue.

But fill the rest of the cast shadow with lots of color. Use color in the same value range, and usually from the same side of the color wheel. However, a warm touch in a cool shadow also works well. ULTRAMARINE BLUE + RAW SIENNA ((GRAYED YELLOW)

SAP GREEN + NEW GAMBOGE

Notice how the shadows appear colder where they meet the sunlit area. Often, cast shadows begin with a hard edge, and then become less distinct as the shadow lengthens.

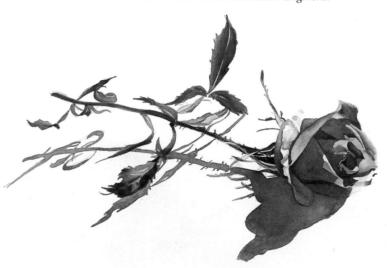

In this painting of a rose, accurate placement of the shadow required great care. To represent sunlight, the cast shadow must be the same hue and 40 percent-plus darker than the object upon which it is cast. In this sketch (as in the one above), the leading edge of the shadow is slightly cooler in color temperature than the body of the shadow shape.

Light penetrating glass can create interesting patterns within the shadow shape. You don't want these intriguing designs to overwhelm your composition, but they can be fun to paint. I usually start by painting the complete shadow shape. Once the paper has dried so the shine is no longer visible, I lift the lighter shapes with a thirsty brush.

Cluster Blooms

Several varieties of flowers, such as hydrangeas and lilacs, consist of clusters of hundreds of individual blossoms. Even if it were possible to render each little blossom, the overall effect might be considerably less than desirable.

The solution I favor is to determine the shape of the overall cluster and paint it first.

After the basic form is complete, suggest individual blooms, making sure that the shape of the original cluster is preserved. Paint the overall shape of the cluster of blossoms. Charge color to show depth and roundness.

Suggest individual blossoms with darker values of the original color. Choose a small area to complete in some detail, and leave the rest "unfinished."

Glazing to Create Distance

Glazing is one way to "set" one flower (or passage) in front of another. I generally use a pale wash of cobalt blue for this purpose. In light values, cobalt blue will form a light haze without destroying the color integrity of the background area.

Other pigments you may consider for this purpose are those that contain no black. Rose madder, cobalt violet and ultramarine blue (in very light values) are three of my favorites. You may find it helpful to experiment *before* you run the wash!

All of the crocus in this sketch are of equal importance. The composition needs a better focus and more interest.

In this illustration, all but the central bloom has been "pushed back." This illusion was accomplished by painting over the background flowers and around the central blossom with a wash of cobalt blue. A different effect can be achieved by beginning with a very light valued glaze and adding successively darker glazes as the flowers diminish in importance.

Convex and Concave Curves

Both convex and concave shapes are often found on the same flower. These curved shapes may be suggested in many ways. One of the best ways to increase the illusion of a curved surface is by cooling the color temperature of an area as it turns from the light.

In this illustration, I used the shape of the petals and the shape of the shadows, as well as the placement of reflected light, to create the illusion of concave and convex surfaces.

> The shape of the shadows, along with the shapes of the petals, and careful attention to color temperature changes suggest convex and concave surfaces. A good drawing is the key here.

Suggesting Form With Line

Line is still another way to suggest surface form. The iris petal appears to curve back, largely because of the vein lines on its surface. A change in color temperature further enforces the illusion. As with everything you paint, observation is the key.

> Line and color temperature can help to suggest curving forms. On this iris, the vein lines, added to the value and color changes, strongly indicate the form of the petals.

Painting Folds and Ruffles

There are several things to keep in mind when painting multiruffled blooms. Not only is the whole flower subject to sun and shadow, but every ruffle and fold moves from direct sun to shade, and then into shadow, many times within one petal. The value changes have to be consistent! There are many opportunities to introduce reflected light.

It's easier than you may think to become so intrigued painting a flower's ruffles and folds that you lose sight of its overall shape. Study your subject carefully. Draw the shadow and highlight shapes. You will probably need to simplify them considerably.

With careful observation, you'll find many opportunities to introduce reflected light. These small areas add more than you would think to the beauty, and the believability, of your painting.

Every petal has dimension: Each has a part facing the light, another facing the sky, and still another in shadow, as well as many areas of reflected light and cast shadows.

Painting Leaves

Leaves are beautiful and deserve a careful look. Most of the leaves you encounter will not be as complicated as the leaf in this illustration. However, leaves that have a prominent place in the floral arrangement should be rendered with as much care as the blossoms themselves.

Add interest and color to leaves by considering first their relationship to the source of light, and using differences in color temperature as a foundation to build on.

WARM GREEN

COOLER GREEN

MOISTEN ALONG THE VEIN LINE AND ADD COLOR TO SUGGEST WHERE THE SURFACE TURNS FROM THE LIGHT.

Above, reinforce color where required and make final corrections. I added some more of the cooler green to the bottom half to retrieve the warm/cool division I set up in the first step. I also developed some of the unique contours of the leaf and darkened some areas along the vein lines to show them more distinctly. At the right, develop the inner contours, maintaining an awareness of the direction of the light.

ADD CAST SHADOWS.

Above, add the cast shadows, keeping a harder, cooler edge on the sunlit side and a softer edge on the shadow side.

SUGGEST PROMINENT RIDGES BETWEEN VEINS.

LEAVE VEIN LINES UNPAINTED.

Painting Watercolor Florals That Glow

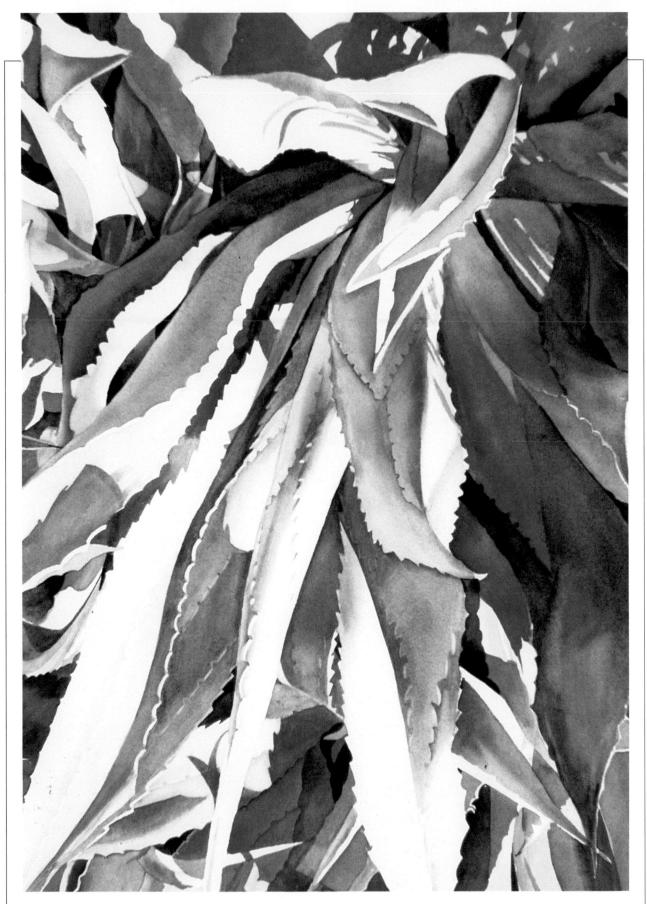

Blue Cactus, 30"x22"

Leaves can make intricately beautiful light-and-shadow patterns. This makes them a good painting subject, either with flowers or alone, like this painting of a cactus.

Dewdrops

Dewdrops are fun and easy to paint. They can add sparkle, but use them sparingly. Note that dewdrops always take on the hue of what they are sitting on.

Step 2: Use a fairly dry brush and a darker-value drop of the petal (or leaf) color into the part of the dewdrop that will face the light. Tip the paper if necessary to keep the color darkest near that end. Let it dry.

Step 1: Draw the dewdrop into position. Wet the spot carefully, almost to the point of creating a puddle.

Step 3: Paint in the cast shadow color at the other end of the drop shape.

Step 4: Use a frisket or knife to lift a rounded highlight at the drop's sunlit end.

Be careful that the dewdrops you paint have their shadow and sunny sides aligned in accordance with the rest of the painting.

"Puddle and Pull"

Step 1: Use a fully loaded brush to

You may find this "puddle and pull" brushstroke as useful as I do when painting pointed leaves and petals.

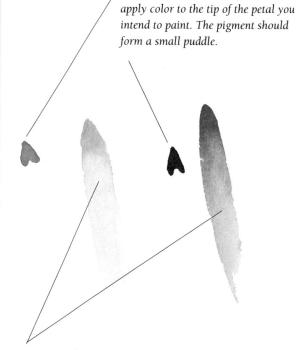

Step 2: Wash out your brush in clear water. Once clean, touch your brush to the paint rag, but permit a moderate amount of water to remain.

Begin the stroke at the bottom of the wet arrow shape, and pull the color down, leaving an ever lighter track. **Step 3:** Let dry before going on to the next petal. Try this stroke when you paint pointed petals.

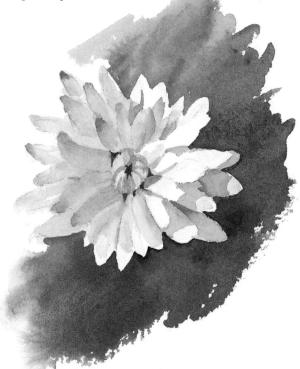

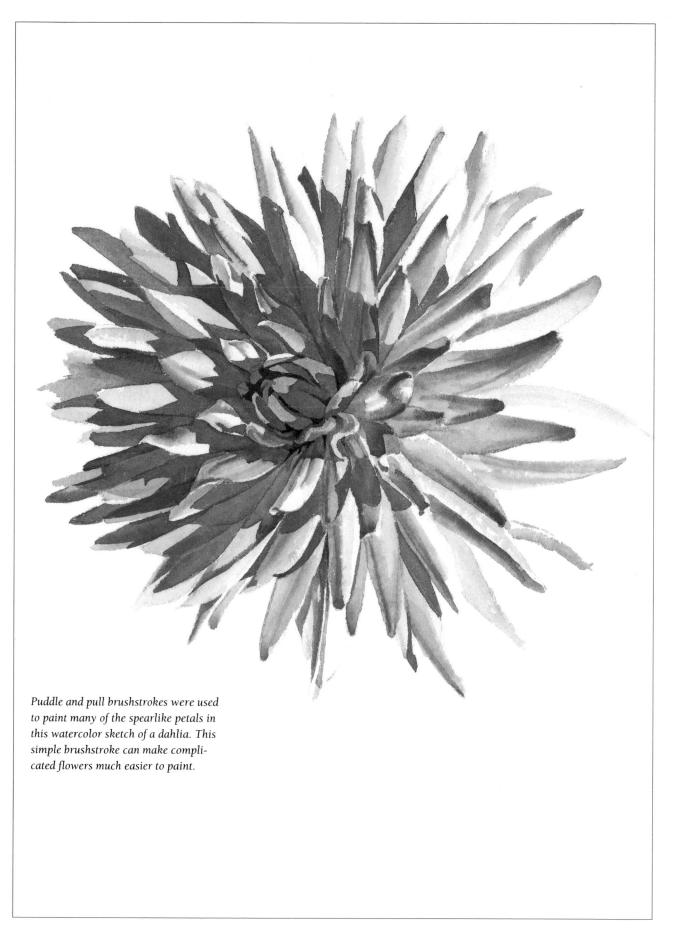

Transparent Surfaces

Glass vases and jars may appear difficult to paint, but they can be surprisingly easy. The trick is to think of the shapes you see within the vase or jar as just that: a collection of shapes that you can paint one at a time.

The cut crystal vase on the next page appears more complicated than this plain glass vase, but the painting method is the same.

Step 1: Study the vase and look for color in the water. Work on a dry surface and paint in the lightest values, letting the colors flood together. Let them dry.

Step 2: Look for darker shapes within the vase. Use the darker values and colors you see, and paint them freely. Here I painted around the stems because their sunstruck side is lighter than the background. If the stems had been darker, I would not have avoided them.

Step 4: Mix a light-value puddle of cobalt blue. Use a clean brush and a light touch to paint over the entire vase, adding more color on the shadow side. Let it dry. Finally, lift highlights

with clean water and a stiff brush. Be sure the highlights follow the contour of the vase.

Step 3: Now it is time to add the stems and leaves within the vase. You can see, I have tried to be fairly careful with these shapes.

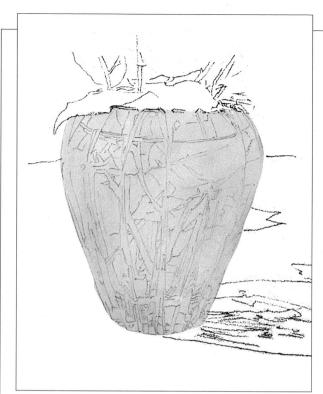

Step 1: Working with a fully loaded brush, begin on the left side of the vase with a pale passage of Winsor blue. Warm the color with ultramarine blue as you approach the other side.

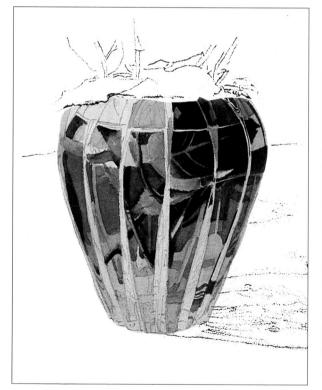

Step 3: Working a section at a time, begin to suggest leaf and stem shapes, now and then making them extend from one area to the next.

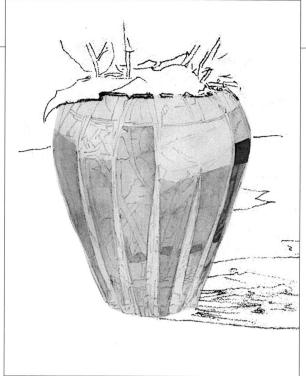

Step 2: This vase is divided into faceted surfaces, providing natural stopping places. Concentrate on reproducing the color and value of each section, using various blues with touches of rose madder.

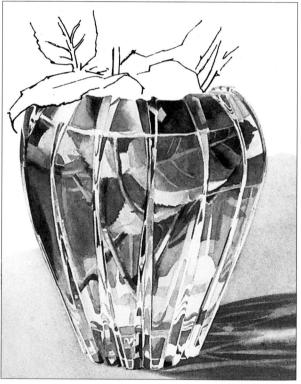

Step 4: Finally, add the dark accents along the edges of the faceted surfaces. The cast shadow comes last. Light streaking through the glass creates soft-edged designs in the shadow area. This illusion can be created by lifting pigment from the previously painted shadow.

Reflective Surfaces

I think successful painting is largely dependent on training your eye to *see*. You need to turn off your conscious brain and paint the shapes you see before you. The shapes in reflective surfaces may not make sense, but they define the surface of the object you are painting. You can do it, and it's fun!

Step 1: Carefully draw the cup, and include any shapes you may see. This teacup is cream colored. The vertical side facing the light is toward yellow, but the horizontal surface of the saucer is more toward green. Let these first washes dry.

Step 2: The shadow shapes are four values darker than the sunny side. They may possess strange shapes, but be as accurate as you can. Make them appear to follow the contour of the surface. Notice that the interior of the cup receives reflected light from the opposite side.

Step 3: Now for the fun part. Paint the extra squiggles you see within the large shadow shapes. Add the gold trim using burnt sienna, new gamboge and alizarin crimson.

Backlighting

Backlighting can make a dramatic and exciting painting. One of the best ways to depict backlighting is to make the petals appear translucent, revealing the light that must be coming from behind them. It may take an object between the flower and the light to complete the illusion. With light from behind, petals appear darker where they intersect, or where a stem or leaf is blocking the direct light. The places where the translucent petals overlap may be slightly lighter than where the foliage blocks the sun.

In this illustration, light appears to penetrate one of the

petals (A) and cast a glow across the shadow area. This illusion was created by painting the shadow side of the petal (receiving the sun) a warmer color than the rest of the shadow. After everything was dry, I glazed yellow over the cool shadow areas to suggest the glow.

Step 1: The cast shadows were painted freely; a few whites show sunstruck areas. The backlighted petal was painted a slightly lighter value and a warmer hue than the rest of the shadow area.

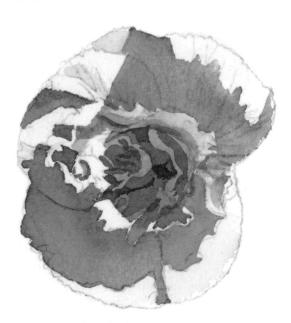

Step 2: Smaller petal shapes in the center were discovered through the same technique described in "discovering background shapes" on pages 82 and 83.

Step 3: Darks and details were added last. To paint the red borders, I began by painting a strip of clear water around the petal's edges and followed it quickly with a thin line of red pigment. The soft borders were created by letting the pigment flow into the wet surface. A backlit flower will usually appear more dark than light. Most of the lighter areas will be at the outside, thin parts of the petals. Many times a darker border will be visible at the edge, as seen here in red.

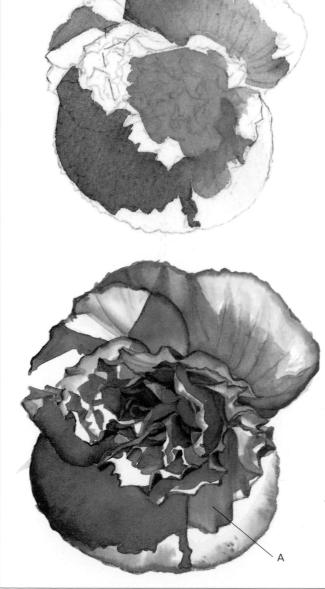

Floral Portraits Step by Step

9

Wildwood Twins, 15" x 20"

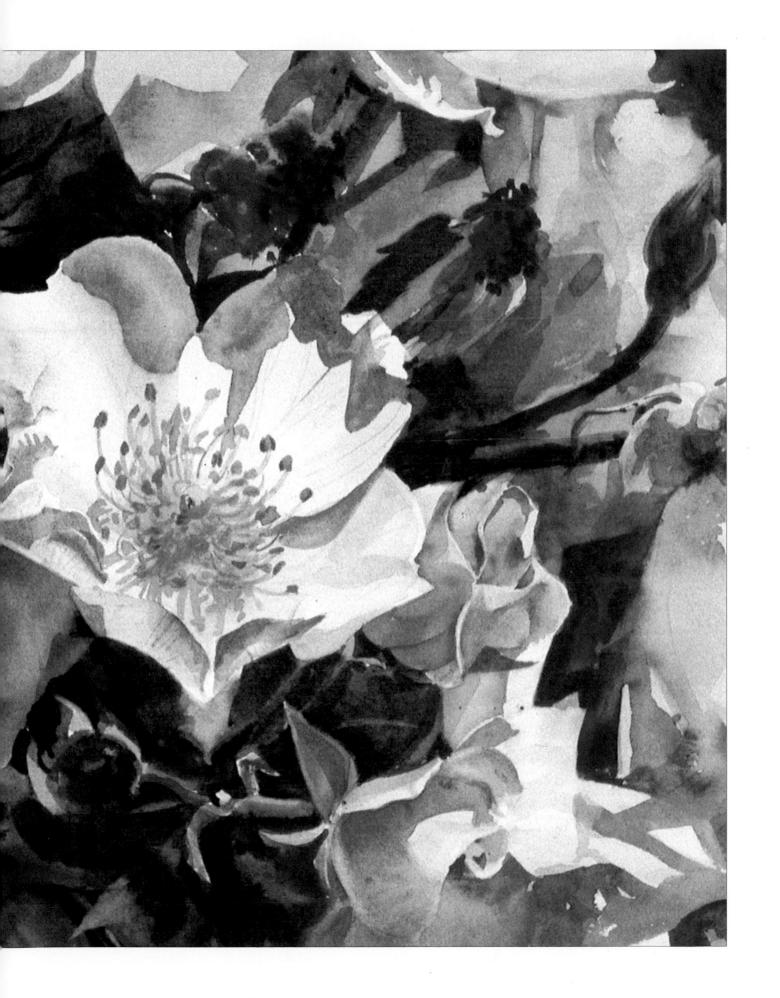

ather than simply show you the steps I go through toward making a finished floral portrait, I would now like to invite you to paint along with me. At the end of this chapter are all of the drawings I used in these demonstrations. You can trace over them, even enlarge them if you wish.

Before we begin to paint these floral portraits, I want to remind you to look first for the flowers' basic forms. As you modify these forms to suit the flower you are painting, think of shapes. The petals and leaves, as well as the planes and folds within them, are basically a variety of shapes.

You will discover that I don't begin every painting in the same way. Generally speaking, I like to work from light to dark. Just like you, I often have to feel my way and make decisions on instinct and experience. The more you paint, the more confidence you will have.

DEMONSTRATION I

Blue Iris Making the Most of Local Color

In this demonstration, you will learn how to enhance a color with the addition of other related colors and still maintain the integrity of the original hue. You may see places where you'll want to employ some of the special floral painting techniques described in Chapter 8. These will include:

- Curled edges receiving reflected light
- Painting convex and concave surfaces
- Painting folds and ruffles
- Painting around complex shapes

The colors are Winsor blue, turquoise blue, ultramarine blue, rose madder genuine, sap green, new gamboge, Winsor green and burnt sienna.

The size of the brush you use should be appropriate to the size of your painting. Often you have a favorite brush, and that is the one you need. For this demonstration, my brushes include a 1" flat, and a #6, 8, 12 and 14 round. This time we will paint directly on dry paper. We will work slowly and feel our way along until we gain confidence.

Step 1: Once the drawing is traced onto the watercolor paper, let's begin to develop the petal in the upper right.

Wet the lower portion of the petal with clear water. Now add a very pale yellow glow to the right side. Don't add this color across the whole petal, just a glow in the bottom corner to suggest direct sunlight. Let it dry.

To suggest the reflected light visible where the petal bends to become vertical, add new gamboge along the length of the bend, and immediately add blue above it. Let the colors blend, then soften the top of the blue edge, and let it dry.

The ruffle at the top comes next. Wet the area. With very little water in your brush (because it's already on the paper), add turquoise blue, Winsor blue and ultramarine blue. Add these colors one at a time, permitting some places to be darker than others to suggest texture.

The cast shadows are value 5 since the petal in sunlight is value 1. Use Winsor blue and turquoise blue on the leading edge and ultramarine blue and rose madder to warm the colors near the center.

Work across the top petal, painting shapes as you see them. A confident brushstroke is important here—no matter if you make a few mistakes. You may be surprised at how good it looks!

Use the same colors and tech-

nique to finish this blossom and begin the next.

The anther in shadow is new gamboge, alizarin crimson, cadmium red, burnt sienna and burnt umber at the center.

Step 2: Continue painting one blossom at a time, using the technique described in Step 1. Remember to use a fully loaded

brush and add colors, one at a time, permitting them to blend on the paper.

Begin the background. Use various combinations of blue, green and yellow. Work on one area at a time, painting carefully around the complex petal shapes. Use the technique described on page 88.

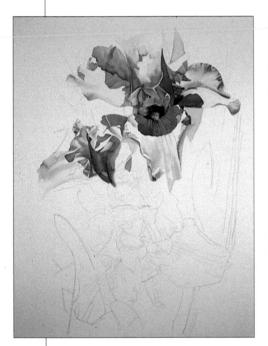

Step 1

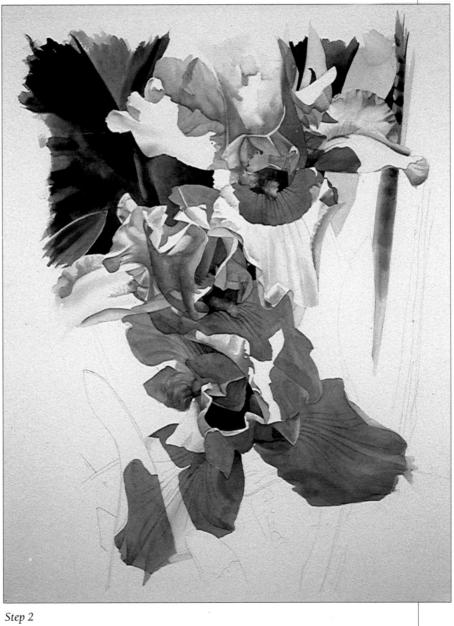

Step 3: Irises are complex shapes, so we want to keep the background simple. Use dark colors close to one another in value. Begin with the medium values and add darker ones. As before, lay the colors next to one another and let them blend on the paper. No mixing in the palette or stroking them together. Keep the greatest contrast between the blossoms and the background.

Step 4: After the painting is dry, develop the spear-shaped leaves, and add any remaining detail.

Once you are finished, survey your work. Ask yourself: Are the value relationships consistent? Have I been careful with the edges? Have I taken advantage of reflected light? What have I learned from this painting to help me on the next?

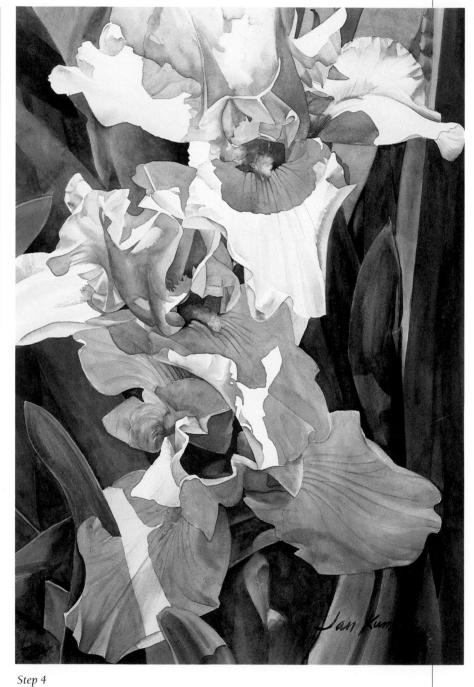

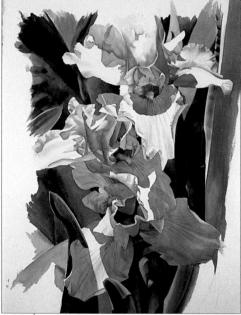

DEMONSTRATION 2

Rhododendrons Painting the Subject Your Way

In the spring, Oregon's coastal forests are filled with rhododendrons in bloom. It is a beautiful sight and a favorite subject for Oregon painters.

It was late in the day when I found these "rhodies." Some of their leaves were lighted from behind by the setting sun. I decided to take advantage of this lighting for my painting and emphasize a brilliantly backlighted leaf.

The things that intrigue you can be the basis for a new, personal approach to your paintings. It could be a spider web on leaves, a dewdrop or perhaps a butterfly. It could even be a torn leaf or unusual lighting. The point is, show it the way *you* see it.

The colors I used in this painting are new gamboge, rose madder genuine, cobalt blue, burnt sienna, alizarin crimson, Winsor blue, burnt umber, raw umber, Winsor green and sap green.

The painting method for backlighted petals on page 105 works equally well for backlighted leaves. The leaves themselves are shown on page 96.

I used #12 and #14 round brushes for the large leaves, and #6 and #8 for the petals. The dark red dots, as well as some small areas, were painted with a #4 round. I worked on a half sheet (15"x22") of cold press watercolor paper. **Step 1:** After the drawing is complete, begin by applying liquid frisket to protect the blossom's stamen. Start with new gamboge along the bottom line of the central blossom's top petal (to suggest reflected light). Immediately add rose madder genuine and alizarin crimson above the yellow passage and let the colors blend. Let it dry.

Next, paint right over the liquid frisket as you complete the blossom.

Step 2: Before you paint the rest of the blossoms, ask yourself if the petal you are painting is facing the sun, turned from the light, or in

shadow. Check for value.

Use the dark red dots on the central petal to help suggest its curving surface. Begin by dampening (page 78) the petal with clear water. Now, lift a gob of fresh alizarin crimson with a small brush, and add the dots. Be careful to position them correctly.

Once a blossom is completed and dried, remove the liquid

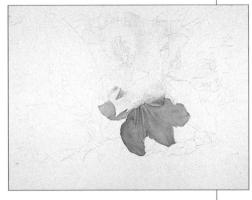

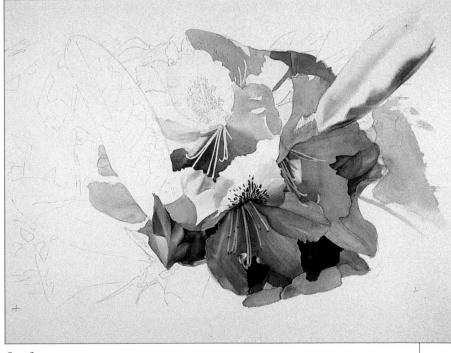

Step 2

frisket. I use a rubber cement pick-up for this purpose, but an eraser will do.

Paint the small, pointed, unformed blossoms at the left of the central bloom by charging various combinations of red, yellow, green and blue onto a dry surface. **Step 3:** Suggest the presence of a distant blossom with combinations of cobalt blue, alizarin crimson and rose madder genuine, and let it dry.

The leaves come next. Underpaint the area with a middle-value wash of cobalt plus a touch of Winsor blue. Let it dry.

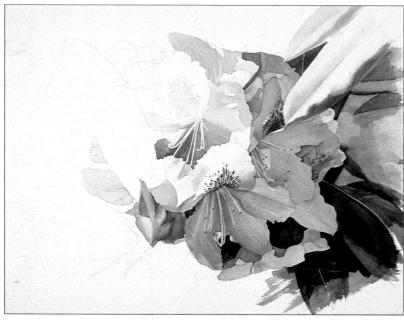

Step 3

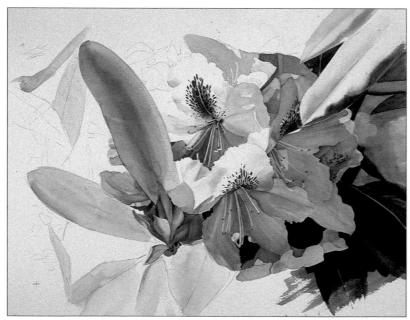

Step 4

Begin at the right edge of the central leaf, and add new gamboge to suggest where the sun glances off its side. Immediately add a darker, grayed green. I use Winsor blue plus a touch of raw umber. Paint only up to the edge of the vein. Complete the rest of the leaves in the same manner.

Step 4: You may wonder, Why underpaint first? It's because certain greens tend to lift and spread if water is added over them. Therefore, if you want light-value veins, they have to be painted first. Once the paint is dry, add the darker color.

Paint the large backlighted leaf with new gamboge along the right edge, and add sap green as you approach the other side. Let it dry.

Step 5: Paint the dark shapes between the veins on the central leaf. Be careful to leave enough of the light underpainting to suggest light coming from behind.

The leaf at the left is in a more or less horizontal position, so the color temperature is cool. Be sure the cast shadow, as well as the leaves in shadow, are dark enough in value.

Once a painting nears completion, it is a good idea to get away, for at least a few minutes, so you can appraise it with a fresh eye.

Can you see how the line of the leaf at the top right (which was intended to point at the central flowers) is beginning to lead the eye out of the composition? **Step 6:** To correct the problem, add another leaf to intersect the offending one. Because the values of the new leaf are darker, it can be added without looking like an afterthought. Finish painting the rest of the leaves.

When you have finished, use your hand to cover the backlighted leaf. With this leaf gone, the painting has become more prosaic, more unimaginative. The simple addition of the leaf presents the subject in a slightly different way. Think of how you can add a personal touch to your next floral.

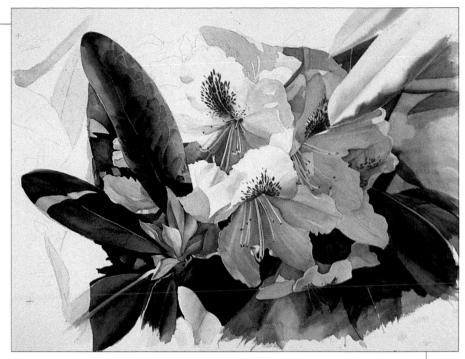

Step 5

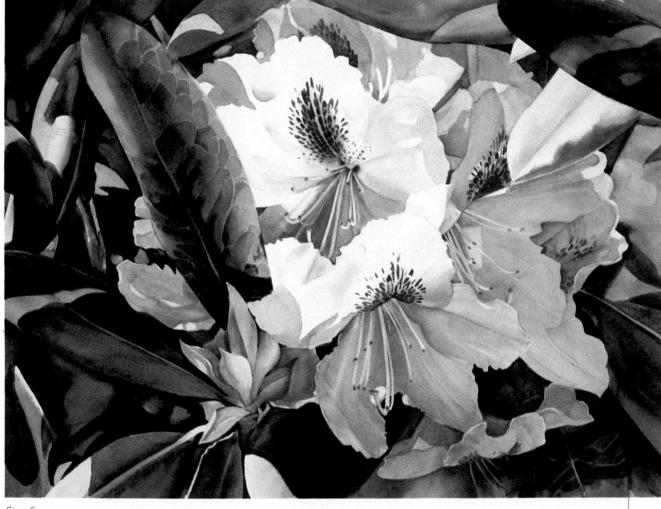

DEMONSTRATION 3

Pink Roses Underpainting for Design Unity

Underpainting can help unify a painting as well as create movement and color. All kinds of exciting possibilities may present themselves for lost edges and much more. You really have to try painting this way to understand how much depth and color underpainting can add to your floral.

In this painting, we will be using several of the painting methods discussed in Chapter 8:

- Curled edges receiving reflected light
- Painting convex and concave surfaces
- Cast shadows

This time I'm working on a half sheet of stretched 140-lb. (15"x22") watercolor paper. The brushes I have set out are a 1½" flat brush for the large wet-intowet wash, along with a collection of smaller round brushes. They range in size from a #4 to a #12.

Our colors are new gamboge, alizarin crimson, rose madder genuine, Winsor blue and French ultramarine blue.

Before we paint, let's think about what we want to do with the wet underpainting. Our objective is to create a soft, abstract structure upon which to hang the flowers. To begin, we must leave some white paper where the roses receive the most light. We want to create an organized pattern of dark-and-light shapes along with a pleasing distribution of both warm and cool colors. Finally, our underpainting must be dark enough to remain visible in the finished painting. To be effective, the underpainting value should be between 3 and 5.

Step 1: Using a large brush and clear water, wet the entire surface of the paper (almost to the point of creating a puddle). Use plenty of pigment because the paper is already wet. Add colors one at a time, remembering to leave some areas free of color. If any color should spread into an undesirable area, do not try to pick up or correct at this time. Your only concern should be to create an interesting pattern of warm and cool colors across the page.

Step 2: After the surface is completely dry, begin to paint the roses. Use a variety of cool and warm red plus new gamboge and red violet. Study each rose and adjust the color temperature for vertical and horizontal surfaces. The cast shadows are a mixture of alizarin crimson, ultramarine blue and new gamboge. Remember, shadows appear coolest at the edge where they meet the light. Keep the overall shape simple, connecting as many shadow shapes as possible.

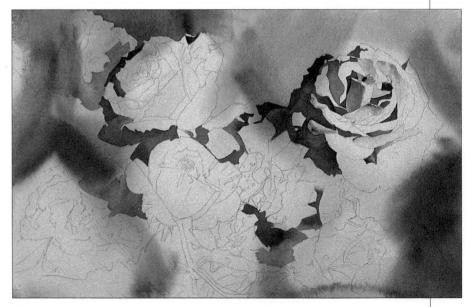

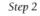

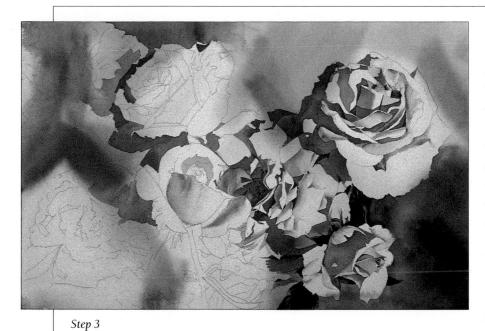

Step 3: Work the shadow sides next and be careful to add reflected light wherever possible. Notice how the wet-into-wet underpainting adds structure and color. Once the surface is dry, you may want to re-wet the background in some places to enhance the color or value. Can you see where I darkened the area around the bud on the lower right?

Begin to develop the stems and leaves at the bottom of the page.

Step 4: Now is the time to add the final darks and make any corrections. Be sure to check the edges.

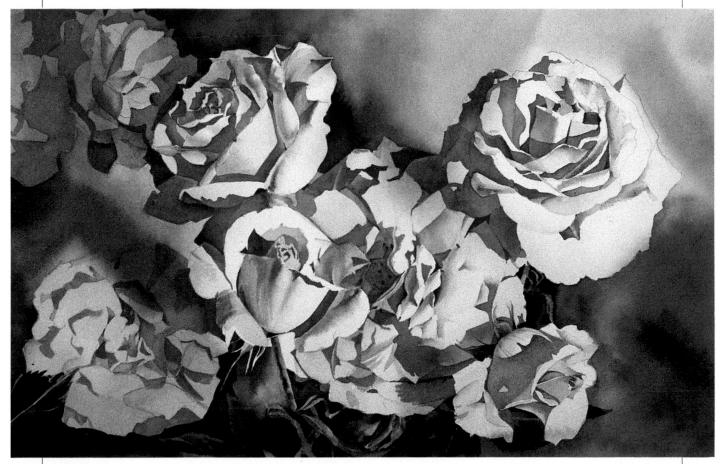

DEMONSTRATION 4

Chrysanthemums Using Contrasting Value, Texture and Color

I have a few pieces of highly prized pre-Columbian pottery given to me by a Costa Rican friend several years ago. The rich brown color and rough surface of the pots contrasts nicely with yellow chrysanthemums from the garden.

In this demonstration, I set up a stage as described in Chapter 4. After everything was in place and lighted, I sketched and photographed the final arrangement.

Even though you will find this sketch on page 125, you may want to "eye ball" the drawing, sketching it loosely. The handmade pots have irregular forms, and the flowers are round shapes with little painted detail.

I am working on a half sheet of Arches 140-lb. cold press paper

that is stretched and stapled onto the drawing board. Brushes include a 1½" flat brush plus the usual complement of smaller round ones: #4, 6, 8, 12 and 14.

You may want to review the sections in Chapter 8 on:

- "Puddle and pull" brushstrokes
- Painting around complex edges

Our colors are brown madder, alizarin crimson, new gamboge, red violet (ultramarine blue plus alizarin crimson).

Step 1: Wet the paper with clear water, and underpaint the area behind the flowers with varying mixtures of brown madder, new gamboge, red violet and alizarin crimson.

Step 2: After the initial wash is dry, use darker values of these same colors to define the edges of the chrysanthemums and stems. Next, add the green leaves with various mixtures of raw sienna, Winsor blue and cobalt blue.

Continue painting individual petals, losing edges wherever possible and adding detail. Now and then, stop to determine if there is enough detail to tell the story without overwhelming the eye.

Wet the foreground area with clear water, and add colors, one at a time, permitting them to merge on the paper. Remember, this is a horizontal surface and should be cooler than the vertical surface already painted. Don't worry if you paint over the pots.

Step 3: When the foreground is dry, paint the sunny side of the large bowl. Work wet-into-wet, avoiding the sunstruck spot on the side. I used alizarin crimson and burnt sienna, adding more

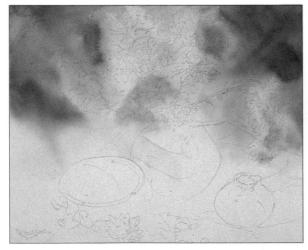

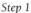

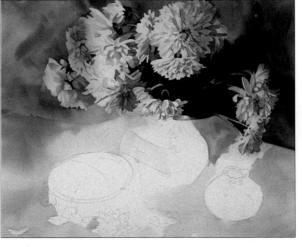

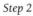

alizarin crimson to cool the surface as it turns from the light. The top portion of this bowl is a slightly different texture. Suggest this difference with a glaze of cobalt blue.

Use these same colors on the small bowl at the right.

Step 4: The shadow side of the bowls is a dark value, so I blocked in the large shadow shapes first. Paint the bowls in the foreground using the same colors and technique as you did on the large bowl. Glaze the inside of the turtle bowl with ultramarine blue to suggest a "used" look. Be sure to keep curved edges soft. Finally, use a stiff, moist brush to lift or correct any highlights.

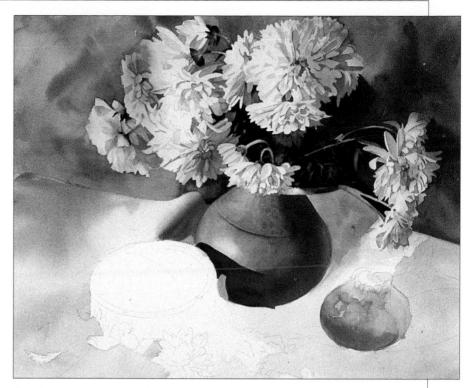

Step 3

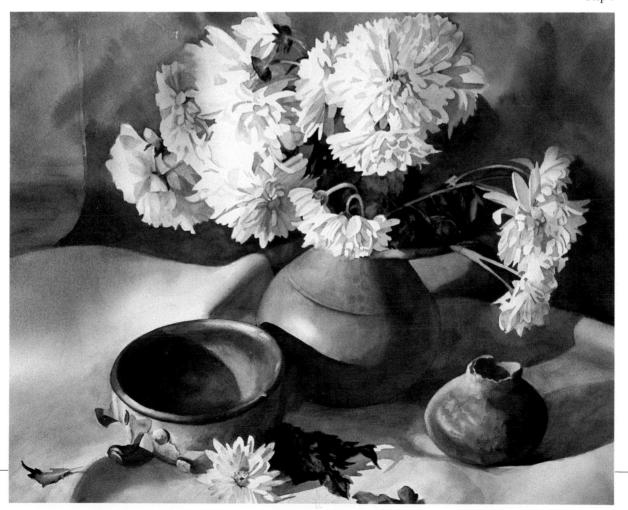

DEMONSTRATION 5

Daisies Painting Reflective Surfaces

This demonstration provides an opportunity to paint several reflective surfaces along with the flowers.

To paint any reflective surface, you may find it best to simply "turn off the left side of your brain" and do as Betty Edwards suggests—just draw and paint what you see. I have described the process on page 104.

Once again, I set up a stage to arrange a setting for the flowers and backdrop.

My colors are Winsor blue, cobalt blue, ultramarine blue, Winsor green, alizarin crimson, rose madder genuine, Winsor red, raw sienna and new gamboge. **Step 1:** Begin with the background. Work wet-into-wet using various blues to create a pattern of color. Leave several white areas for the daisies, but darken the outer corners of the paper to keep the eye within the page.

Step 2: As soon as the surface is dry, begin painting the daisies. Darken the color around some petals, letting them appear to emerge from the background.

Next, develop the fold in the background drapery. Wet the area and then add color, letting your brushstrokes follow the direction of the fold.

Step 3: Underpaint the lightest value of blue on the vase and lid. Add darker shapes as they appear. To paint any reflective surface, think only of the shapes you see, and reproduce them as carefully

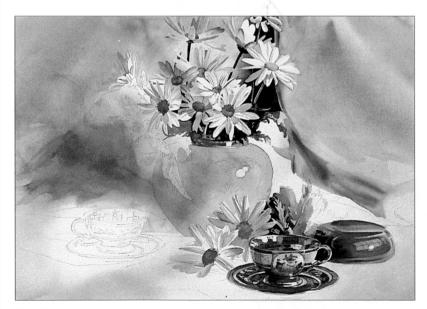

Step 3

Step 1

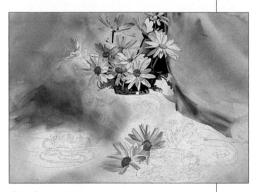

Step 2

as possible. Use raw sienna, new gamboge, burnt sienna and rose madder to suggest the gold color on the cups.

Step 4: Begin with the large vase. Paint blue-green on the right side and add a cooler blue toward the center. Use a fully loaded brush, and keep a wet edge as you work across the surface. Paint around the circular highlight and the rectangular reflection. Make sure the brushstrokes follow the contour of the vase. Add darker color as you approach the shadow side.

The cups require a careful look. Examine the color and the shapes you see. Take them one shape at a time and they become manageable. *Step 5*: Re-wet the background area left of the vase. Use bold brushstrokes of color across the background and into the vase itself. Let the colors merge and be lost in one another.

Now for a final appraisal. If the background drape is demanding too much attention, make it less important with a glaze of cobalt blue and rose madder. To set the drape back farther still, add leaves to intersect (and break the thrust) of the fold.

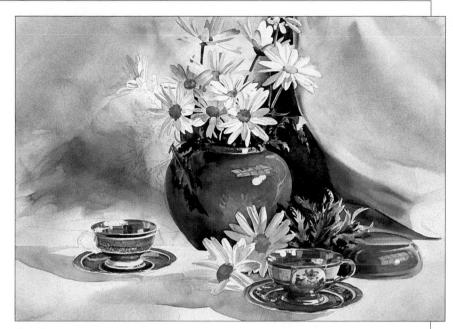

Step 4

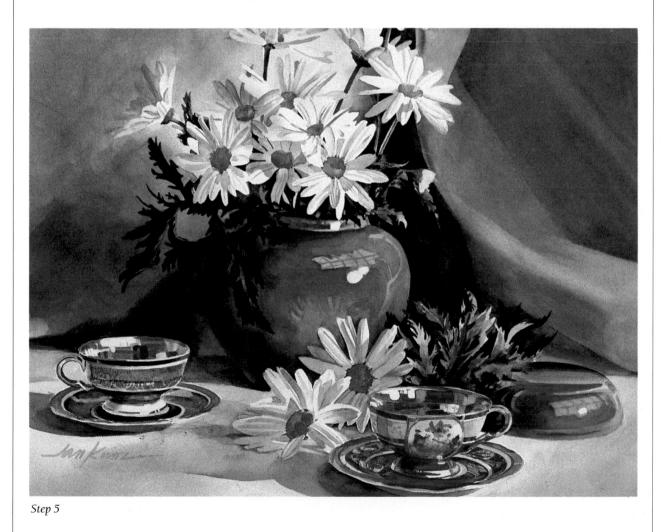

DEMONSTRATION 6

Poppies Discovering Shapes Within the Composition

In this painting, we will draw the principal flowers in position, but not the foliage. The placement, as well as the shapes of the foliage, will be developed from the design opportunities found in the wetinto-wet underpainting.

I know this may sound like voodoo art, but it is possible to see shapes within a wash, especially in a charged wash. This is what we will attempt to do in this painting. You may understand this concept better if you look at "discovering background foliage" on pages 82 and 83.

These beautiful poppies make a wonderful subject for a floral painting. They look as if they were made of white crepe paper. I have seen them as large as a salad plate.

The colors are new gamboge, alizarin crimson, burnt sienna, ultramarine blue and Winsor blue.

I am working on a full sheet (22"x30") of 300-lb. cold press watercolor paper. I have set out large brushes as well as smaller ones for this painting.

Step 1: Wet the entire paper with clear water. Paint warm and cool shapes across the page using considerable pigment in your brush.

Step 1

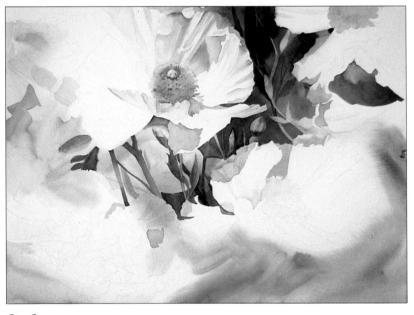

Step 2

Try to avoid at least a part of the flower shapes. Your finished wash should be about value 4. Let it dry.

Step 2: Your background will differ from mine. That is as it should be. No two washes are exactly the same.

After the wash dries, begin to paint the flowers by darkening the background colors around them. Next, study your painting and look for subtle shapes within the wash. Go slowly and use your imagination to add stems and leaves as you "find" them. Make the most of the background shapes you have created.

Step 3: Continue developing the flower shapes and adding detail. Look for places where you might lose an edge. This is a good way

to make the background a part of your painting. Ask yourself if you should glaze back an area, soften an edge or add a stem.

An unforeseen circular shape has developed behind the central blossom in my painting.

Step 4: I use that white shape to suggest another flower. Overlapping shapes help give the illusion of depth. The final step is to survey your work. Are the value relationships consistent? Are the darks dark enough? Use your value scale to check again.

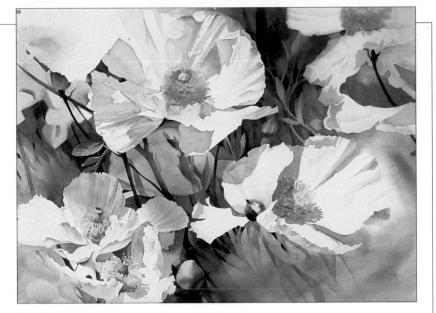

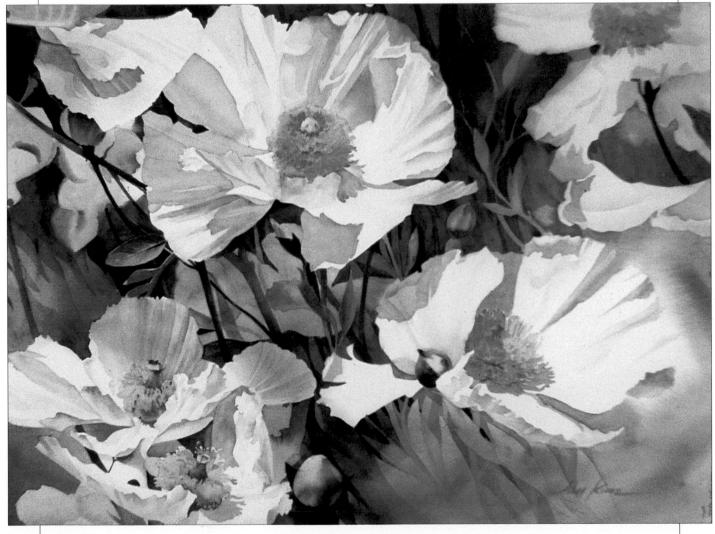

Drawings

Since you have read this far, you are no doubt ready to paint a floral masterpiece! At least I hope so!

As promised, here are the drawings I used in the painting demonstrations earlier in this chapter. I have made a grid over them to make it easy for you to enlarge them and paint along with me. If you have not enlarged a gridded sketch before, this is how you do it:

Count the number of squares in the sketch, and draw an equal number of larger squares on your sketch paper. Next, copy the floral drawing, one square at a time. Enlarging a drawing in this manner can make the most complicated sketch manageable.

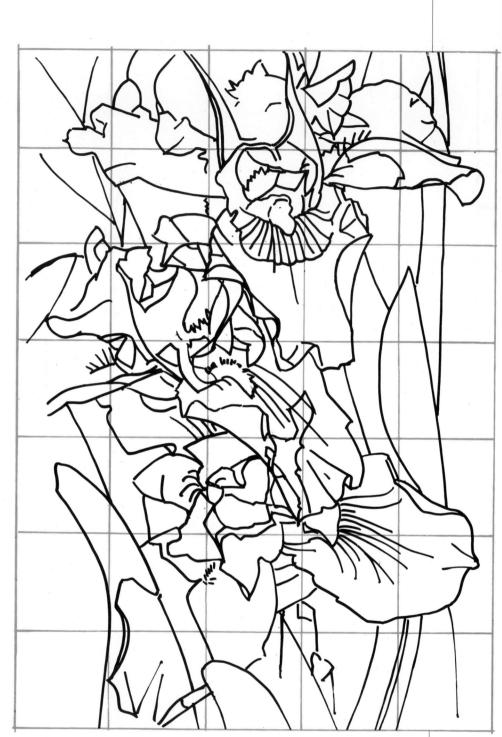

IRIS

This is the drawing for the iris on pages 109-110. I suggest you look at the painting as you draw and include only the lines you want. Some of the shapes are confusing. I was intrigued by the way the swordlike leaf cut through the petal of the bottom iris. The line across the petal is its cast shadow.

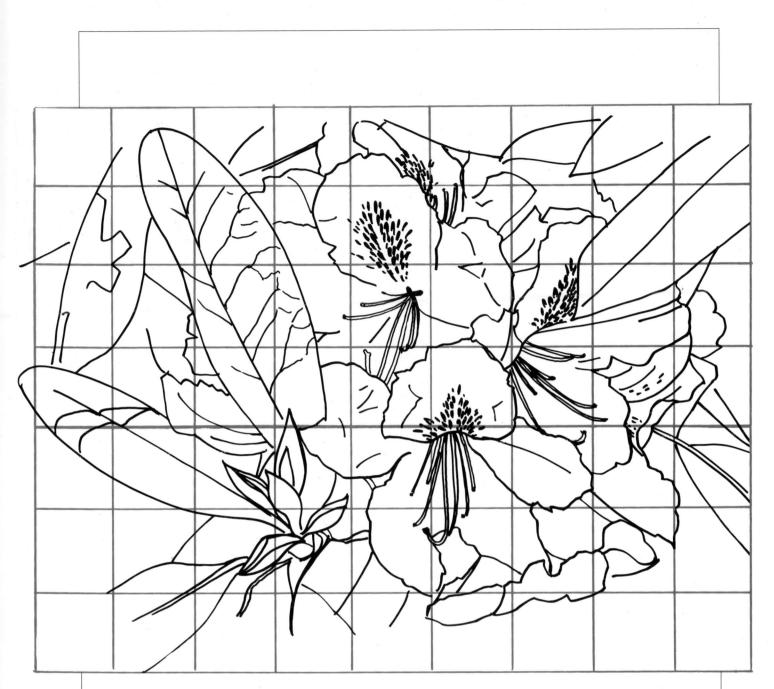

RHODODENDRONS

This painting will give you an opportunity to experiment with various greens. Remember, when you mix complementary colors in dark values, you can get mud. To create a grayed green, I find it best to lay complements next to one another and let them blend on the paper.

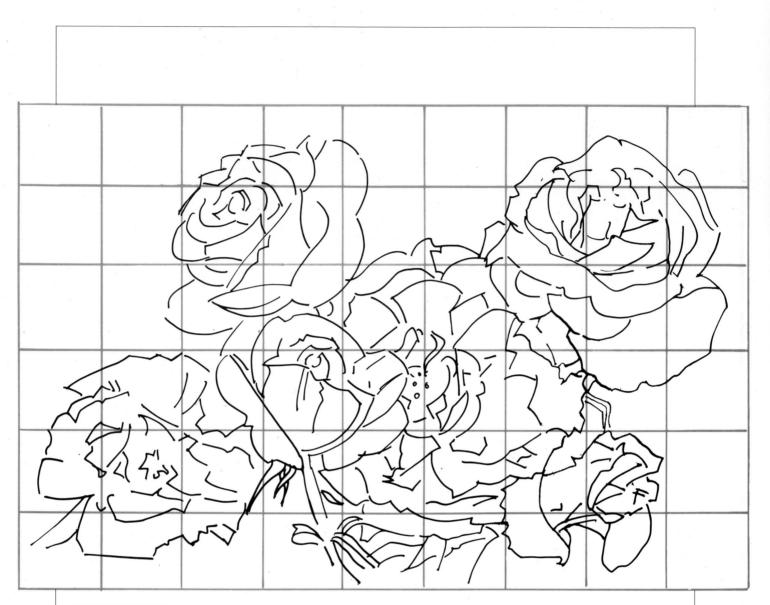

PINK ROSES

I began the painting of the roses on pages 114-115 with a wet-into-wet underpainting. It is a good idea to make the drawing dark enough so the lines will be visible under the wash. If you lose them, they can be reinstated any time during the painting process.

CHRYSANTHEMUMS

I drew a great deal more information into this painting than I used. The shapes are simple. The position of the various objects is about all that is needed. Nevertheless, if more drawing makes you feel comfortable—do it!

DAISIES

This is the kind of painting I like to start when the house is quiet and there is little chance of interruption. If you are new to painting, I suggest you make the drawing large enough so you can see where you are going. Take your time—you'll do a great job.

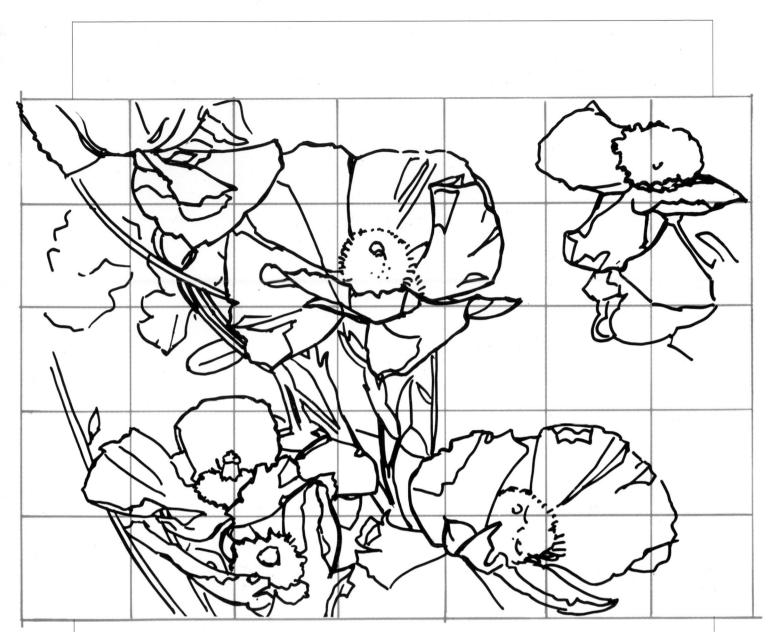

POPPIES

Here is a chance for you to begin with my demonstration painting and add enough of your own creation to make it uniquely your own! Why not start big? You may want to add this painting to your collection.

Reference Photos

Here are a few photographs of flowers that may inspire you to try your hand at floral painting. Feel free to trace over these photos to help yourself get started.

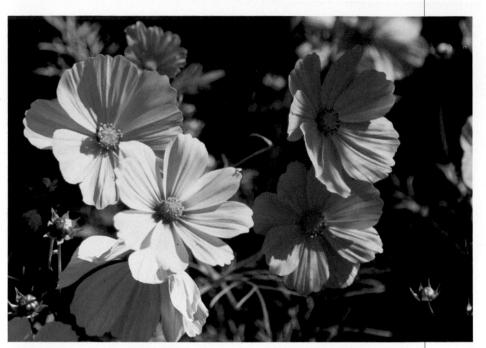

This photo of cosmos would make a better composition if the flower on the lower right were moved a bit to the left.

I would begin painting these flowers with an abstract wet-into-wet underpainting.

These apple blossoms make a nice path across the page. Watch out for those bold anthers. Handle them carefully or they could make your painting look spotty!

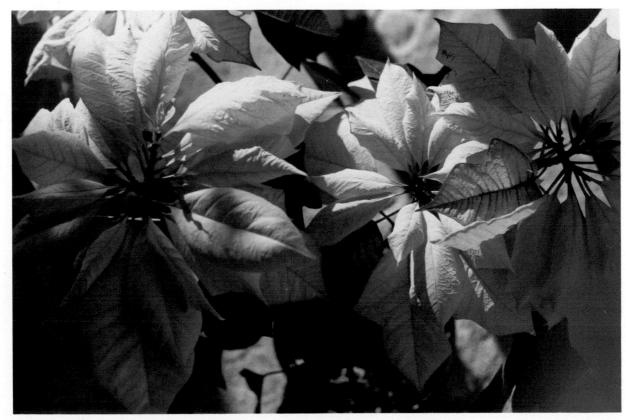

These white poinsettias need a bit of rearranging, but this photograph has great possibilities.

The "One-Two-Threes" of Floral Painting

t the beginning of this book, I suggested that there is no simple "one-two-three" way to paint flowers. However, every floral painting we complete does go through three phases of development. The success of the painting is largely dependent on how much thought we have given to each phase.

PHASE ONE

Planning

Study the subject. Know the subject well enough to be able to draw the blossoms and leaves in any position.

Design the picture area.

R Make an S.A.T. sketch, and design the whole picture area. Decide on a vertical or horizontal format.

Plan the distribution of color and value. A quick color sketch can spotlight potential problems. Use vertical lines to work out a pleasing value plan.

PHASE TWO

Drawing

B

Make a full size drawing.

Begin the drawing on tracing paper and use as many overlays as necessary to work out all the bugs.

Transfer the final drawing.

Transfer the drawing onto the watercolor paper using the graphite sheet you have made for this purpose.

PHASE THREE

Painting

Prepare the work space.

Have everything ready before you begin. You will need fresh pigment, clean water and a paint rag positioned where you have immediate access.

Decide on a painting method.

This is where you have to feel your way. If there are a great many complicated shapes, you should consider starting on dry paper. Perhaps a wetinto-wet wash is the best way to begin. Go with your instinct.

Always take all the time you need.

In the final analysis, we paint with our brains. There is no substitute for thinking! So take your time and enjoy every step of the way.

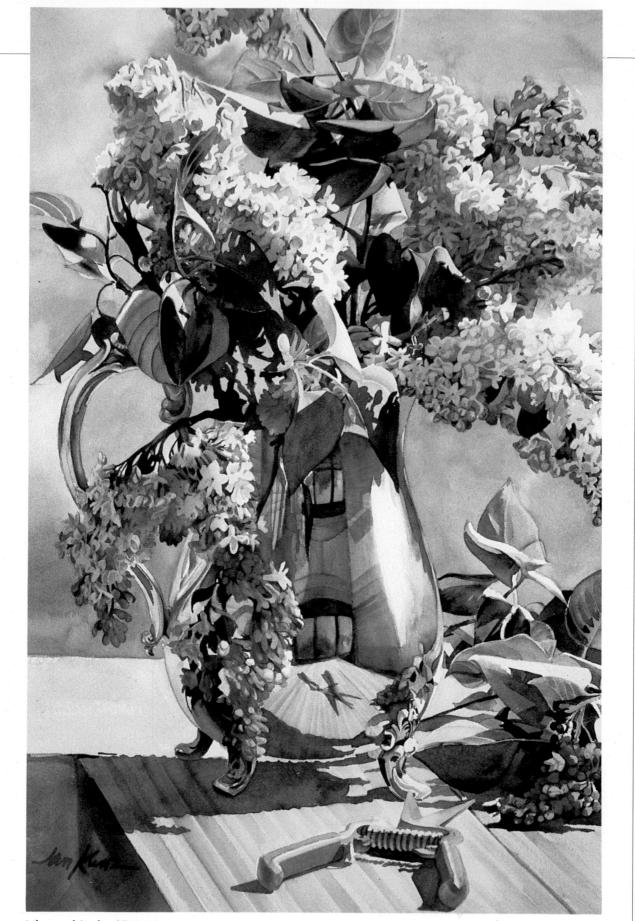

Lilacs and Sterling, 30"x22"

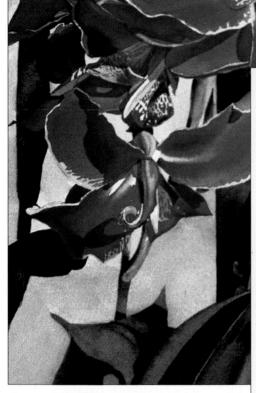

Cannas, 30" x 22"

Conclusion

Now and then, even the best of painters will experience times when nothing seems to go right. One artist friend described it as a time when you need to look for your own name in the phone book to see if you are somebody! When this happens, try to be relaxed. It has been my experience that this may be a period of growth and that you will come back better than ever.

One student sent me a photo of her car. The licenseplate holder read, "Not afraid of sap green." Watercolor painting is full of small victories, but the best reward is always the joy of painting!

Conclusion 133

Index

Acetate, frosted, 6

Backgrounds, 82-83 simple, 109-110 Backlighting, 105 leaves, 96, 111, 113 Backyard Daisies, 57 Balloons. See Run-backs Blooms, cluster, 91 Blue Cactus, 97 Bougainvilleas, 2-3 Brush, fully loaded, 78-79 Brushes, types of, 4-5 Brushstroke, "puddle and pull," 100-101 demonstration of, 116-117

Cactus Flower, 89 Cannas, 133 Cast shadows, 70-71, 90 demonstration of, 114-115 and shadow sides, 75 Chrysanthemums demonstration of, 116-117 drawing of, 125 stems, 35 Color, 12-13 charging, 80-81 enhancing, with color temperature, 74 planning distribution of, 130 Color temperature, 13 enhancing color with, 74 suggesting curving form with, 94 and sunlight, 70-73 Color wheel, 12 Columbine, 10-11 Complementary colors, 13 Composition discovering shapes within, 120-121 elements of, 56 Cone, as basic form, 22 Cone-shaped flowers, 28-29 Cool colors. See Color temperature Cropping, 62 Cube, as basic form, 22-23 Curves, convex and concave, 93 demonstration of, 114-115 Cut flowers, finding, 38 Cylinder as basic form, 22-23 and disk shapes, in daffodils, 30-31

Daffodils, cylinder and disk shapes in,

30-31 Daisies, viii Daisies, 25 demonstration of, 118-119 drawing of, 126 Dampen, defined, 78 Darks crevice, 71 and detail, modeling, 75 Demonstration blue iris, 108-110 chrysanthemums, 116-117 daisies, 118-119 pink roses, 114-115 poppies, 120-121 rhododendrons, 111-113 Depth, 62 Dewdrops, 98 Diagram, of flower parts, 20 Direction. See Lines Disk-shaped flowers, 24-25 Distance, creating, by glazing, 92 Dominance, 58-61 Drawings of demonstrations, 122-127 making and transferring, 131 Dusty Roses, 66-67

Edges, of shadow, 90 Edges, complex, painting around, 88-89 demonstration of, 116-117 Edges, curled of leaves and petal, 86-87 reflected light on, demonstration of, 108-110, 114-115 Elements of composition, 56 Enlargement, using grid to make, 122

Facial tissues, need for, 5 File, scrap, 48 Flowers arranging, 40 cut, 38 diagram of, 20 multi-shaped, 30-33 photographing, 48-49 silk, 38 with simple forms, 24-29 where to look for, 38 *See also* Chrysanthemums; Daisies; Iris; Poppies; Roses, pink; Rhododendrons Folds, painting, 95 demonstration of, 108-110 Foliage, background, 82-83 *See also* Greens Form basic, 22-23 simple, flowers with, 24-29 suggesting, with line, 94 40 percent rule defined, 14 and value, 68-69 Fox glove, conical shape of, 28

Glass. See Surfaces, transparent Glazing, to create distance, 92 Graphite transfer paper, making, 7 Greens mixing, 123 painting lush, 84-85 Grid, using, to enlarge drawing, 122

Hue, defined, 12 Hyacinth, conical shape of, 29

Iris blue, demonstration of, 108-110 drawing of, 122 two spheres in, 32-33

Knife, X-Acto, or razor blade, need for, 5 Kwansan Cherry Blossoms, 46-47

Leaves backlighting, 96, 111, 113 curled edges of, 86-87 painting, 96-97 stems and, shapes of, 34 See also Foliage, Greens Light, reflected, 70 curled edges receiving, 86-87 demonstration of, 108-110, 114-115 Lighting, 41 determining direction of, with "never-fail nail," 49 flat, 49 Lilacs and Sterling, 132 Lines, 62-63 suggesting form with, 94 Liquid frisket, 5 use of, 111-112

Magnolias, 54-55 Matte acetate. See Acetate, frosted Maxi Mums, 59 Moisten, defined, 78 Mt. Fuji Cherry Blossoms, 42-43

"Never-fail nail," determining light direction with, 49

Oil brushes, modified, 4-5 Opaque pigments, 13 *Oregon Gold*, 18-19 Overlapping, and dominance, 61

Paint, types of, 8 Paint rag, need for, 5 Painting floral, phases of, 130-131 method of, deciding on, 131 in stages, keeping edges soft when, 88-89 Painting tips, 8-9 Paintings, several, from single photo, 52 Palette and paint, cleaning, 9 selection of, 5 Pansies, 36-37 Paper stretching, 6-7 transfer, 7 watercolor, types of, 6 Peace Rose, 85 Pencils, 5 Peonies, 27 Petals curled edges of, 86-87 painting, with fully loaded brush, 80-81 Photo S.A.T. sketch and, 64-65 single, getting several paintings from, 52 Photo collection, acquiring, 48 Photographing flowers, 48-49 Photos combining, 50 reference, 128-129 Picture area, designing, 56-57, 130 Pigment, defined, 12 Pigment chart, 15-17 Pigments, watercolor, 13 chart of, 15-17 Pink Roses, 65 Planning, importance of, 130 Poppies

demonstration of, 120-121 drawing of, 127 Precipitating pigments. *See* Opaque pigments Primary colors, 12 Print film, vs. slides, 49 Props, 40 Puddle, defined, 78 "Puddle and pull" brushstroke, 100-101 demonstration of, 116-117

Reflected light, 70 on curled edges, 86-87 Reflections, sky, 70, 74 Reflective surfaces, 104 demonstration of, 118-119 *Rhodies*, 60 Rhododendrons demonstration of, 111-113 drawing of, 123 Roses, pink demonstration of, 114-115 drawing of, 124 Ruffles, painting, 95 demonstration of, 108-110 Run-backs, 79

Scrap file, 48 Secondary colors, 12-13 Shadow sides, and cast shadows, 75 Shadows, adding, 87 Shadows, cast, 70-71, 90 demonstration of, 114-115 Shapes of cluster blooms, 91 complex, painting around, demonstration of, 108-110 of flowers, 20-21 repeated, dominance by, 58 within composition, discovering, 120-121 See also Form Silk flowers, 38 Sisters, The, 83 Size, and dominance, 60 Sketch S.A.T., 64-65 See also Drawings Sky reflections, 70, 74 Slides, vs. prints, 49 Sphere-shaped flowers, 26-27 Spheres as basic form, 22-23

two, flowers with, 32-33 Spring Bouquet, 63 Stage, building, 44-45 Staining pigments, See Transparent pigments Stems, and leaves, shapes of, 34 Studio. See Work space Subject attraction to, importance of, 111 study of, 130 Sunday Afternoon, 83 Sunlight, and color temperature, 70-73 Sunny Daisies, 62 Sunny Side Up, 76-77 Surfaces, convex and concave, 93 demonstration of, 114-115 Surfaces, reflective, 104 demonstration of, 118-119 Surfaces, transparent, 102-103

Tips, painting, 8-9 Transfer paper, 7 Transparent pigments, 13

Underpainting for design unity, 114-115 purpose of, 112

Value defined, 13, 68 and dominance, 63 planning distribution of, 130 Value scale, 69 Values, mixing brilliant, 14 Viewpoint, 41 Views, panoramic, avoiding, 49

Warm colors. *See* Color temperature Wash, charged, 82 Water, deciding how much, 78-79 Watercolor paper, types of, 6 Watercolor pigments, 13 chart of, 15-17 Wet, defined, 78 Wet-into-wet charging color, 80-81 underpainting, 114-115 Wetness, scale of, 78 *Wildwood Twins*, 106-107 Work space preparing, 131 well-organized, 8-9

Improve your skills, learn a new technique, with these additional books from North Light

Artist's Market: Where & How to Sell Your Art (Annual Directory) \$22.95

Watercolor

Basic Watercolor Techniques, edited by Greg Albert & Rachel Wolf \$14.95 (paper) Buildings in Watercolor, by Richard S. Taylor \$24.95 (paper) The Complete Watercolor Book, by Wendon Blake \$29.95 Fill Your Watercolors with Light and Color, by Roland Roycraft \$28.95 How to Make Watercolor Work for You, by Frank Nofer \$27.95 The New Spirit of Watercolor, by Mike Ward \$21.95 (paper) Painting Nature's Details in Watercolor. by Cathy Johnson \$22.95 (paper) Painting Outdoor Scenes in Watercolor, by Richard K. Kaiser \$27.95 Painting Watercolor Portraits That Glow, by Jan Kunz \$27.95 Painting Your Vision in Watercolor, by Robert A. Wade \$27.95 Splash I, edited by Greg Albert & Rachel Wolf \$29.95 Splash 2: Watercolor Breakthroughs, edited by Greg Albert & Rachel Wolf \$16.95 Tony Couch Watercolor Techniques, by Tony Couch \$14.95 (paper) The Watercolor Fix-It Book, by Tony van Hasselt and Judi Wagner \$27.95 Watercolor Impressionists, edited by Ron Ranson \$45.00 The Watercolorist's Complete Guide to Color, by Tom Hill \$27.95 Watercolor Painter's Solution Book, by Angela Gair \$19.95 (paper) Watercolor Painter's Pocket Palette, edited by Moira Clinch \$15.95 Watercolor Tricks & Techniques, by Cathy Johnson \$21.95 (paper) Watercolor Workbook: Zoltan Szabo Paints Landscapes, by Zoltan Szabo \$13.95 (paper) Watercolor Workbook: Zoltan Szabo Paints Nature, by Zoltan Szabo \$13.95 (paper) Watercolor Workbook, by Bud Biggs & Lois Marshall \$22.95 (paper) Watercolor: You Can Do It!, by Tony Couch \$29.95

Webb on Watercolor, by Frank Webb \$29.95 The Wilcox Guide to the Best Watercolor Paints, by Michael Wilcox \$24.95 (paper)

Mixed Media

The Art of Scratchboard, by Cecile Curtis \$10.95 The Artist's Complete Health & Safety Guide, by Monona Rossol \$16.95 (paper) The Artist's Guide to Using Color, by Wendon Blake \$27.95 Basic Drawing Techniques, edited by Greg Albert & Rachel Wolf \$14.95 (paper) Basic Landscape Techniques, edited by Greg Albert & Rachel Wolf \$16.95 Basic Oil Painting Techniques, edited by Greg Albert & Rachel Wolf \$16.95 (paper) Being an Artist, by Lew Lehrman \$29.95 Blue and Yellow Don't Make Green, by Michael Wilcox \$24.95 Bringing Textures to Life, by Joseph Sheppard \$19.95 (paper) Bodyworks: A Visual Guide to Drawing the Figure, by Marbury Hill Brown \$10.95 Business & Legal Forms for Fine Artists, by Tad Crawford \$4.95 (paper) Calligraphy Workbooks, (2-4) \$3.95 each Capturing Light & Color with Pastel, by Doug Dawson \$27.95 Colored Pencil Drawing Techniques, by Iain Hutton-Jamieson \$24.95 The Complete Acrylic Painting Book, by Wendon Blake \$29.95 The Complete Book of Silk Painting, by Diane Tuckman & Jan Janas \$24.95 The Complete Colored Pencil Book, by Bernard Poulin \$27.95 The Complete Guide to Screenprinting, by Brad Faine \$24.95 Tony Couch's Keys to Successful Painting, by Tony Couch \$27.95 Complete Guide to Fashion Illustration, by Colin Barnes \$11.95 The Creative Artist, by Nita Leland \$21.95 (paper) Creative Painting with Pastel, by Carole Katchen \$27.95

Drawing & Painting Animals, by Cecile Curtis \$26.95

Drawing For Pleasure, edited by Peter D. Johnson \$16.95 (paper)

Drawing: You Can Do It, by Greg Albert \$24.95

Exploring Color, by Nita Leland \$24.95 (paper)

The Figure, edited by Walt Reed \$16.95 (paper)

Fine Artist's Guide to Showing & Selling Your Work, by Sally Prince Davis \$17.95 (paper)

Getting Started in Drawing, by Wendon Blake \$24.95

Getting Started Drawing & Selling Cartoons, by Randy Glasenbergen \$19.95 The Half Hour Painter, by Alwyn

Crawshaw \$19.95 (paper)

Handtinting Photographs, by Martin and Colbeck \$29.95

How to Paint Living Portraits, by Roberta Carter Clark \$28.95

How to Succeed As An Artist In Your Hometown, by Stewart P. Biehl \$24.95 (paper)

Keys to Drawing, by Bert Dodson \$21.95 (paper)

Light: How to See It, How to Paint It, by Lucy Willis \$19.95 (paper)

Make Your Woodworking Pay for Itself, by Jack Neff \$16.95 (paper)

The North Light Illustrated Book of Painting Techniques, by Elizabeth Tate \$29.95

Oil Painting: Develop Your Natural Ability, by Charles Sovek \$29.95 Oil Painting: A Direct Approach, by Joyce

Pike \$22.95 (paper) Oil Painting Step by Step, by Ted

Smuskiewicz \$29.95

Painting Animals Step by Step by Barbara

Luebke-Hill \$27.95 Painting Floral Still Lifes, by Joyce Pike

\$19.95 (paper)

Painting Flowers with Joyce Pike, by Joyce Pike \$27.95

To order directly from the publisher, include \$3.00 postage and handling for one book, \$1.00 for each additional book. Allow 30 days for delivery.

North Light Books 1507 Dana Avenue, Cincinnati, Ohio 45207 Credit card orders Call TOLL-FREE 1-800-289-0963 Prices subject to change without notice.